PUBLISHED BY CHAUCER PRESS
20 BLOOMSBURY STREET, LONDON WC1B 3JH

© CHAUCER PRESS, 2004
REPRINT 2005

ISBN 1 90444 927 1

A COPY OF THE CIP DATA IS AVAILABLE FROM THE
BRITISH LIBRARY UPON REQUEST

DESIGN: POINTING DESIGN CONSULTANCY
SCANNING AND COLOUR REPRODUCTION: OPEN DOOR LIMITED AND GA GRAPHICS, STAMFORD

PICTURE CREDITS: IMAGE OF SIR ROY STRONG BY PAUL BRASON PPRP RWA 2002
PAGE 14: ANON, GERMAN, 16TH CENTURY, 17: EDWARD TOPSELL, 1607,
21: EDWARD LEAR, 22, 26, 29, 30, 35: JOHN TENNIEL, ALICE BOOKS

BIBLIOGRAPHY: 'THE QUINTESSENTIAL CATS' BY ROBERTA ALTMAN
'THE LIFE HISTORY AND MAGIC OF THE CAT' BY FERNAND MERÉRY
'MARTIN LEMAN: A WORLD OF HIS OWN' BY DAVID BUCKMAN
'STARCATS' PUBLISHED BY PELHAM BOOKS
'SLEEPY CATS' PUBLISHED BY ORCHARD BOOKS
'CURIOUSER AND CURIOUSER CATS' PUBLISHED BY VICTOR GOLLANCZ
'COMIC AND CURIOUS CATS' PUBLISHED BY VICTOR GOLLANCZ

MARTIN LEMAN'S
CATS

ROBIN DUTT

FOREWORD BY
SIR ROY STRONG

CHAUCER PRESS
LONDON

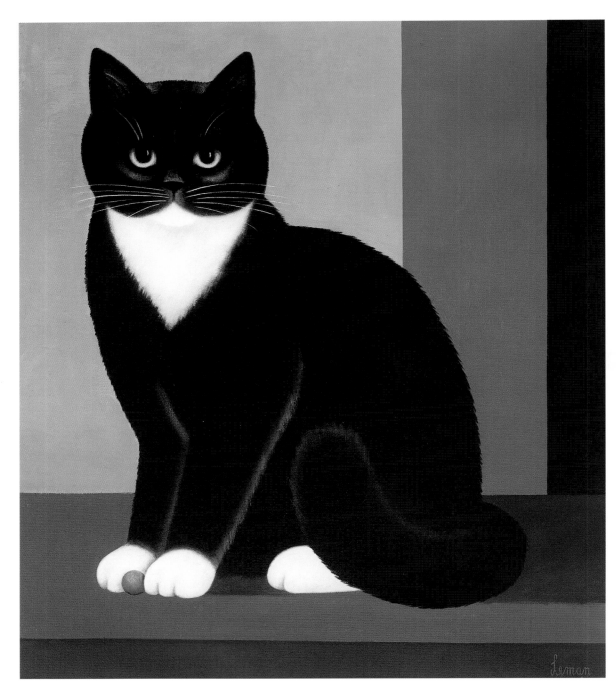

La Balle Rouge
Oil on board, 2003
Private collection

CONTENTS

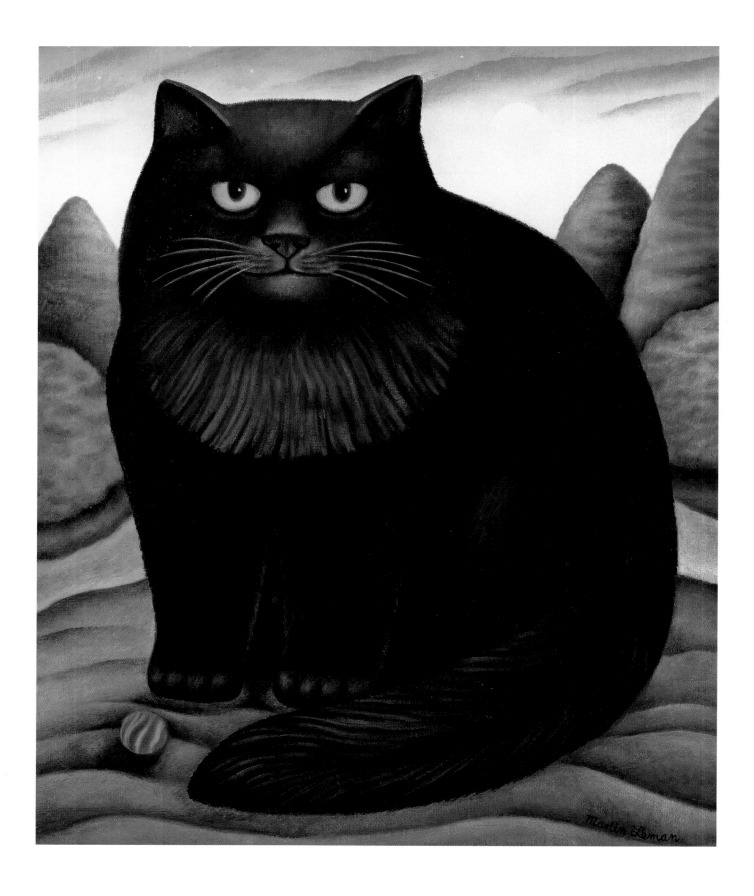

FOREWORD BY
SIR ROY STRONG

I FIRST BECAME aware of Martin Leman's work in the late 1970s when a tortoise shell cat decided that she would take up residence with us. I had always loved cats. Indeed they instinctively come to me as their long lost friend. My wife, however, had to learn to love them, which she did. Which leads me to the point I wish to make, that you have to be cat fixated to appreciate to the full the miraculous powers Martin Leman has when it comes to feline portraiture.

The Lady Torte de Shell, as she became, was special, but not as special as her successor, the Rev. Wenceslas Muff, this time a rescue, a magnificent long-haired black monster who for over decade was the spirit of the house. And with his advent we have arrived in the early 1980s and the appearance of the first anthology of Leman cats I know of, *The Perfect Cat* (1983). Others followed and I think I have the lot. That 1983 book I gave to my wife as one of her Christmas presents that year. Its contents entranced me and it must have been not long after that I met Martin at a book fair, if I remember rightly, at the Victoria & Albert Museum, of which I was then Director.

The Reverend Wenceslas Muff
Oil on board
30 x 25 cm
Commissioned by Sir Roy Strong

That was the preface to my commissioning the portrait of Muff in 1985 as a birthday present for my wife. In it Muff sits on a grassy knoll with a river and some trees behind him with a star spangled sky above. As in so many of Martin's cat portraits there is a little ball at his feet. I am touched that Martin included this beloved creature, who is, alas, no more, in two of his books. Not a bad way to be immortalised. This year we added to the gallery a second commission, one of the late William Larkin, Esq., of The Laskett, another mega-cat, this time a splendid if cantankerous Maine Coon. He too has a ball at his feet. Otherwise Larkin is depicted on a ledge flanked by views, appropriately for me, towards a topiary garden. In a strange way the result in both cases is a cross between a Byzantine icon and a painting by Douanier Rousseau.

I can think of few other contemporary painters who have this strange empathy for cats, who are able so powerfully to distil the essence of cat onto canvas or paper. One was the late E. Box, whose cats always had human eyes. She didn't in fact like cats. Another is Elizabeth Blackadder, skilled in catching the sleek movement of the creatures. But neither have quite the hypnotic quality of Martin's images.

William Larkin Esq. of The Laskett
Oil on canvas, 2003
Collection of Sir Roy Strong

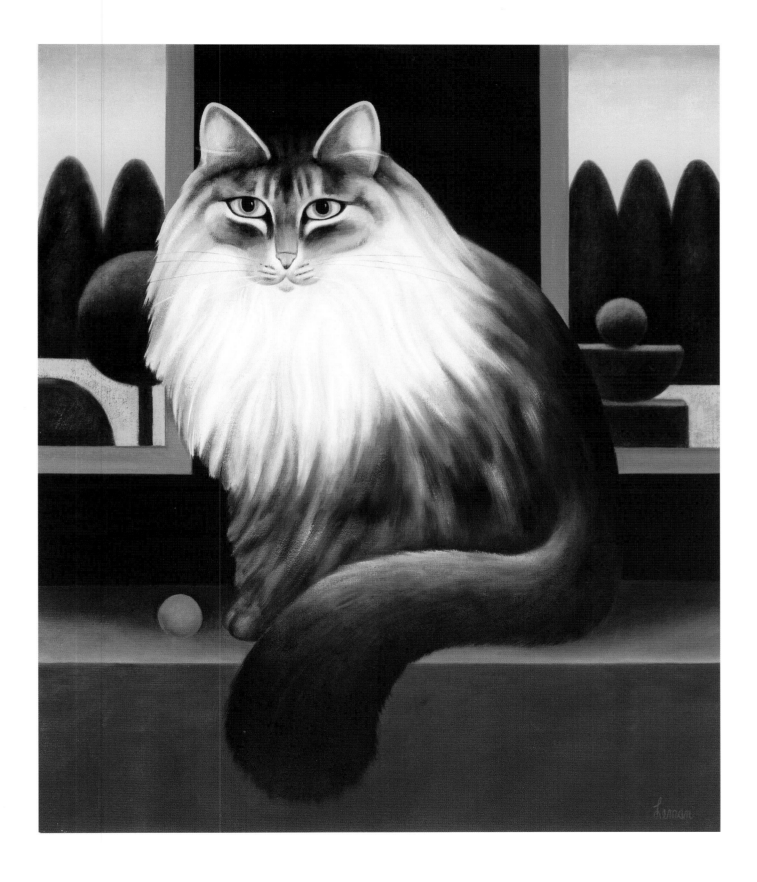

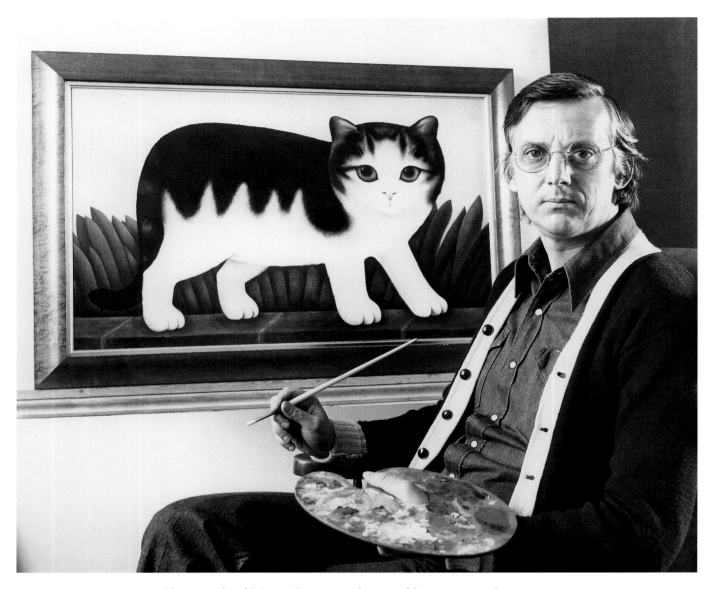

Photograph of Martin Leman with one of his paintings, late 1970s

I suppose that I'm drawn to them also for their resonances of two other kinds of painting from which I have never ceased to gain delight. One is Tudor and Jacobean portraiture. No, not the grand court stuff, but the anonymous provincial portraits, abstract compilations composed of patterned textiles, embroidery, lace and jewellery into which stylised renderings of the face and hands have been set. The other is early American portraiture. These depict awkward doll-like figures set into a 'through the looking-glass' world, where the perspective is all over the place and only contributes to the resulting image being even more two-dimensional. But the result is never other than beguiling.

This is true of Martin's cats. Cats excite him and that is reflected in what he paints. A Leman cat virtually always looks you in the eye. They are self-contained creatures, imperious in their way. There is no sentimentalisation. They are definite and uncompromising. A Leman cat struts his or her stuff and is never apologetic. They dominate the picture's surface and their setting is subservient to them. These are records of beings who have been or still are huge personalities in the lives of their owners, as worthy of being accorded a portrait as any human being. In some instances more. And of all this Martin Leman is only too well aware as he essays yet another apotheosis of the cat.

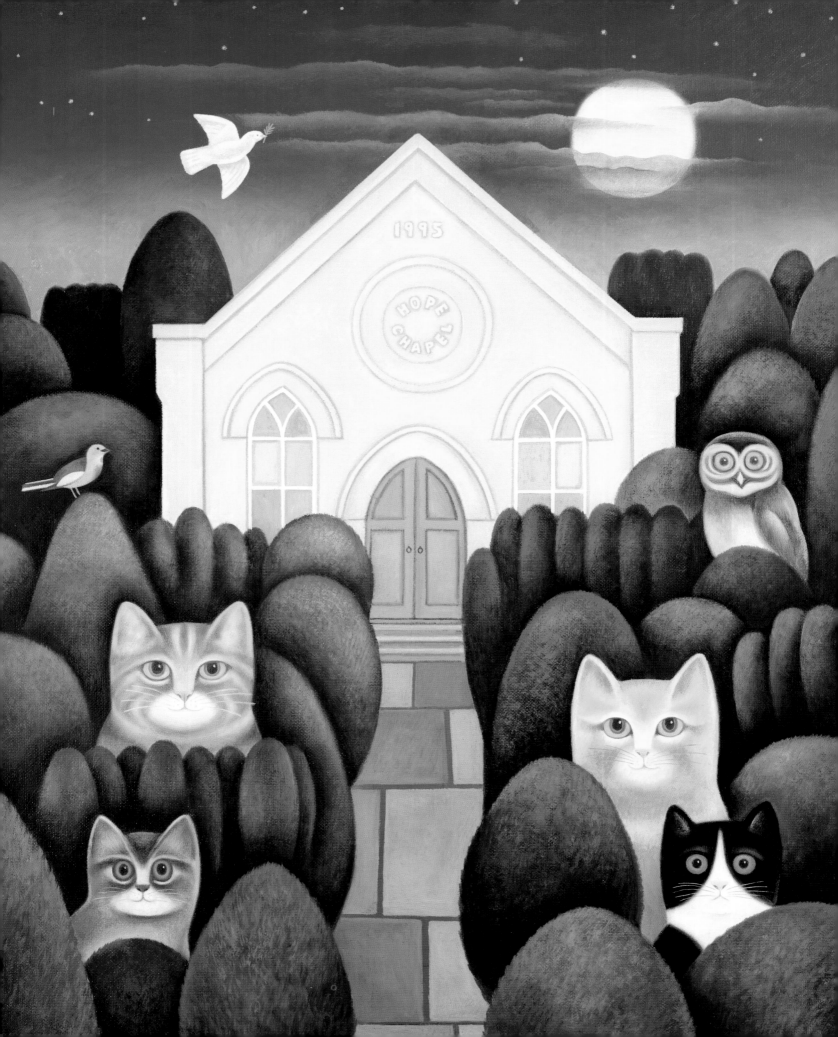

Introduction

I am the cat that walks by himself
And all places are alike to me.

Rudyard Kipling

CATS. THEY ARE EVERYWHERE. Strolling with or without purpose along a car-lined street; basking on a tin roof not quite made uncomfortably hot by the noon-day sun; a Whitby jet black example dangling a balletic yet faintly comic leg over a tree branch, like a miniature panther; a Tortoiseshell fluffy lazing among the nibbled cabbages. Cats insinuate themselves into our lives and we are so familiar with them that we take them for granted – as denizens of a shared world where we are both equal. To question their presence seems like insolence.

Like Cleopatra, the species enjoys 'infinite variety' – from the classic 'Heinz 57' no-pedigree mix up to the 36 recognised pedigree breeds. Think of a cat and unless it is or was a favourite or recently seen, chances are that several will occur, one after another. Their colouration, patterning, texture and very shape invites interested comparison and contrast. Also, we just may feel like identifying ourselves with the character and temperament we often ascribe to them. Of course, cats have their distinct characters, which veer away from their shared, natural characteristics. Tabby cats seem never to leave sun-drenched back gardens. Pure black cats do seem to know that they have an air of Art Deco magic and mystery. We assume that Persians are going to be haughty – and they often are. And as for the Abyssinian – we can't quite believe such a shape can exist.

Peaceful Evening
Oil on board, 1994
38 x 25 cm
Collection of John Maxwell

Cats appear in books, as company logos, in advertising campaigns (and not simply those for cat food), as car mascots – and indeed, car identities to boot, as works of art, swinging pub signs and discreet or mystical symbolic jewellery.

Our desire to align ourselves with this species is perhaps, all too understandable, especially when one looks at the cat family, the Felidae in its entirety from scraggy lap moggy to svelte, veldt leopard. It is believed that the cat's most early ancestor was Miacis – a creature more akin to a weasel or stoat, which thrived 50 million years ago and curiously is also the ancestor of the dog too. But typically, of course, cats were around millions of years before the first recognizable canine. One only has to think of the prehistoric and hugely impressive sabre-toothed tiger.

Hardly any other type of creature has so many converging, diverging and unpredictable guises. Dog lovers may not quite agree of course, citing variety and very human traits in their canine friends. But there is one major difference. Whereas domesticated dogs seem to 'know their place' and are somewhat happy with the imposed hierarchy, cats could never submit to a pyramid of power where they were not at the top – even if they give the impression of being dependent in some way on their human friends.

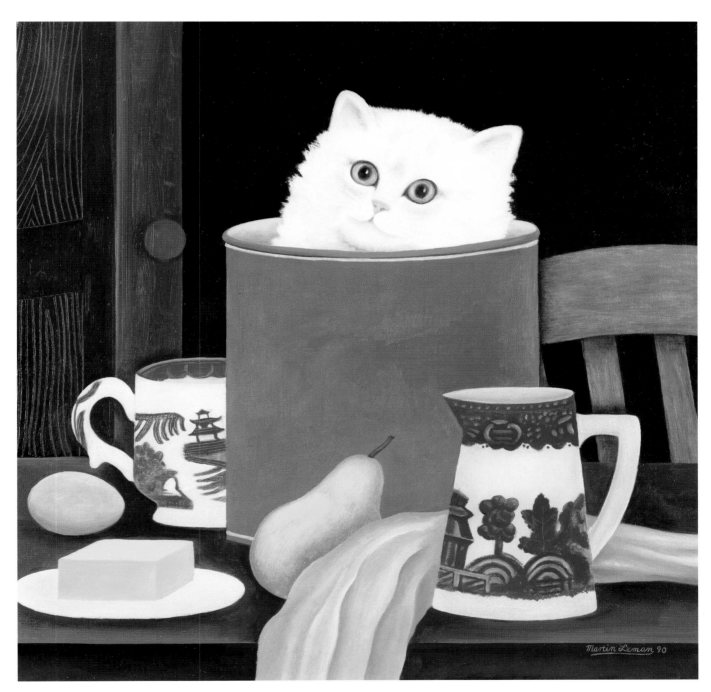

White Kitten
Oil on board, 1990
30 x 30 cm
Private collection

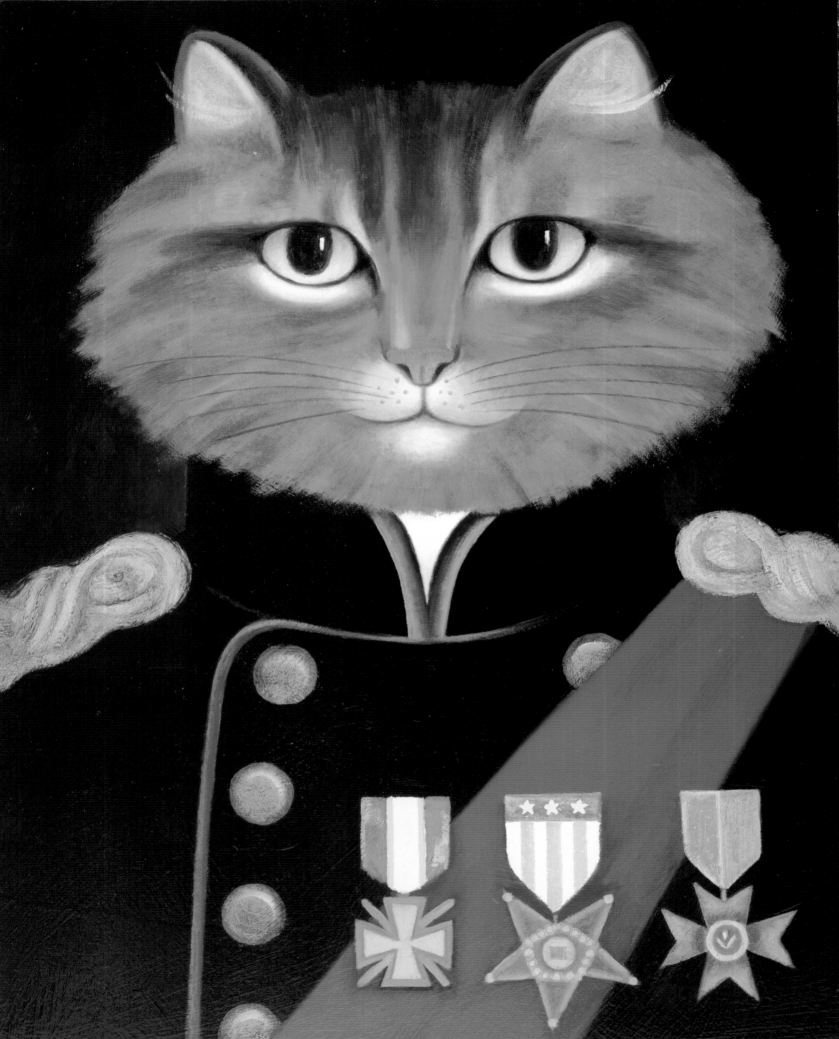

From divinity to deceit, fierce loyalty to often fiercer independence, stay at home or play away wanderlust addict, the multifarious nature of the cat neatly echoes in so many ways, the complexity of the human spirit and psyche.

A cat might sit on the mat but it also leaps in a fierce and feisty attempt to snatch a passing butterfly dancing about the Buddleia. A cat looks relaxed stretched out on a sizzling summer lawn but is always ready to run. Its soft fur belies its sharp teeth; its suede-soft paws conceal rose thorn claws. Its silky voice can suddenly turn shrill – almost alarmingly and weirdly human – as anyone knows who has heard night time cats calling to one another beneath darkened bedroom windows. Caterwauling, by any other name? Plainly, we admire these creatures. And a good reason why is because they are so mysterious, inscrutable and unpredictable. That steady, staring gaze seems so confident and assured. On the other hand, cats are disliked or even despised. And yes, one can be allergic to them or even have a phobia about them. How catastrophic. Cat clichés abound – on a par with ones involving dogs, the two animal types to have had so much ascribed to them. 'Not enough room to swing a cat', 'Not to have a cat's chance in Hell', and 'There are more ways than one to swing a cat', are hardly complimentary. 'As weak as a cat', is not particularly kind – or true and 'Who's she, the cat's mother?' not particularly salutary. It does, however, convey the intent.

But whatever the emotion, we cannot ignore them. For every disingenuous thing said about them, there is a bouquet to compensate, further emphasizing their complex and indeed, sophisticated natures.

The General
Oil on board, 2002
41 x 31 cm
Private collection

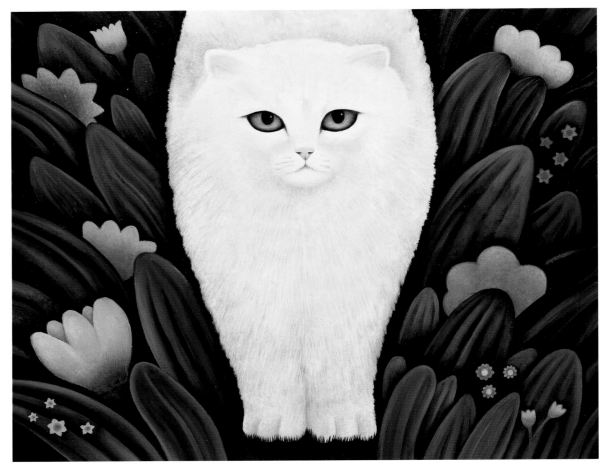

Cat in the Garden
Oil on board
35 x 30cm
Private collection

Cats are natural allies of the night – their eyes specially developed to cope with pitch. When those little road reflectors were invented to shine in the beam of a car's headlights on unlit country roads, what else could they have been called? But this connection with the dark leads to one with magic, the unknown and even the divine.

It may come as little surprise to remember just why several ancient civilizations celebrated the cat or the 'big cat' as a significant deity and worshipped as such.

According to the earliest records, cats were domesticated some 8,000 years ago but they had to wait another 4,000 years before becoming fully so. Their natural sense of self and independence and also the fact that unlike dogs, they are not natural pack creatures meant that they did not take so kindly to such a constraint. This deliberate self-possession was seen perhaps by the ancient world as reason enough to respect them. And respect surely turned to reverence and worship.

The deification of the cat is most readily associated with the ancient Egyptians who created laws to protect them. Cat worship developed and was to last for over 2,000 years, centring on the figure of Bastet – a sensual, mystical, goddess with the body of a woman and the head of a cat. Often presented alone or surrounded by kittens, Bastet came to symbolize sensuality, fertility, grace and beauty. Her main temple was at Bubastis where cat worship became something of a spiritual art form and thousands of cat mummies were preserved there, along (thoughtfully enough) with mouse mummies to provide the former with a few snacks on the journey into the afterlife. One excavation alone yielded over 300,000 cat mummies.

During the Pharonic reign, it was a capital crime to harm a cat, even if there was no malice aforethought. If a cat should die of natural causes, the mourning was intense and elaborate in the extreme – many families going to the extent of shaving all their body hair as a mark of respect. An inscription on the royal Theban tombs runs thus –

> Thou art the Great Cat, the avenger of
> The gods and the judge of words and president
> Of the sovereign chiefs and the governor of
> The Holy Circle. Thou art indeed the
> Great Cat.

Beautiful and useful (as vermin hunters) they came and went as they pleased when all other animals were owned. They enjoyed the same respect then as the cow still does today in Hindu India. Forbidden to export them from Egypt, they did begin to spread around the globe originally around the Mediterranean on board ships as companions and mousers and then overland by caravan to India, China and Japan. It is hard to think perhaps of that ball of fur curled up on that cushion as having had not just a place in the pantheon of gods but as the 'governor of the Holy Circle'. Incidentally, the Egyptian word for cat is 'mau' – surely a vocalization of the familiar sound of its voice.

But from greatness, royalty and reverence of the ancient world, the cat's fortunes began to change by the time of the Dark Ages and Mediaeval period. At this time of a distinct lack of knowledge and tolerance, the cat was actively singled out as an instrument of evil and in some cases – especially of jet-black cats – the devil himself. Cats were associated with witchcraft and perhaps it was the very arrogance and haughtiness, which the ancients respected which others detested and feared.

A witch was often identified as having a 'familiar' – a helpmate from the other world, often in the form of a cat and of course, often black. How many innocents living in remote cottages with a broomstick in the kitchen corner and a cat by the fire were burned at the stake is unbearable to imagine. Into the flames of course, also went the cat. At this time and with their new identity of being on best terms with the Devil, cats were religiously hunted down and tortured. Live cats were sealed inside walls of houses for luck and on religious feast days, they might be burned alive as part of the 'celebrations'.

But by curious dint of Fate, the cat was to have the last laugh. Senseless human action of destroying cats led to one obvious conclusion – the rise of the rodent population and following this, the destruction of grain and other food sources and

the spread of multifarious plagues throughout Europe. The usefulness of the cat as understood by the Egyptians was only realized when men, women and children started dying in their thousands. A cat's curse perhaps?

By the seventeenth century, cats were welcomed back to the hearth and home and prized again for their hunting prowess. Indeed, it became fashionable to own and breed them, particularly the more decorative and more difficult breeds with long hair that needed constant attention. By the late nineteenth century Queen Victoria owned two, cat shows were established, and in the US, cat fanciers banded together into organizations.

Cats began to be celebrated in literature, especially poetry and children's stories and song. And although an implausible, impossible situation, who cannot recall the delightful union of Edward Lear's 'The Owl and the Pussy Cat' and if not word perfect, then certainly, remember the warmth and joy of the fantastical imagery as they 'danced by the light of the moon'.

A cat is often the first pet a child is given – well usually, it is a kitten. And often they can and do live a long time, just about seeing their masters and mistresses (one uses these titles lightly, of course) off to university – and even welcoming them back. Apart from the oh so easy charms of the fun fair goldfish which is remote to say the least, the kitten or cat is often the first animal children learn from. How it grows, how its character develops, its affection, its moods, its thought processes, its manners and of course, its demise.

This is all education and because the cat is so full of character it has inspired many artists and musicians through the ages. Albrecht Dürer, Leonardo da Vinci, Paul Gauguin, William Hogarth and Pablo Picasso all represented them and then who can forget those paintings and cartoons from the celebrated pens of Louis Wain and the animators who created Tom and Jerry, Felix, Sylvester and the Cat in the Hat. Stroll down most China Towns in most cities around the world and you will see variations of the Japanese Maneki-Neko – the cat of good fortune with its paw raised almost in salute. Some battery operated ones actually wave continuously. Martin Leman sees in his cats, volumes of inspiration and information. It is an interest, which cheerfully borders on the obsessive.

In conversation with the artist, a dry, wry almost self-amused smile plays on his lips when thinking of just how very much our Felis Catus has influenced him. He empties box after box of transparencies of his painted cats – in all their guises – remembering each one with affection and a deep interest. This one was a commission, that one a spark of twilight inspiration, that one simply for fun, this one because it had to be done.

So tangible is a cat's shape, form, being that it must come as little surprise that it is the single most utilized animal to advertise products of all sorts, all over the world. A cat is instantly domestic-friendly, familiar, a foregone conclusion and interestingly as sexually relevant to male and female potential customers. The man might admire the stealth, lithe, purposeful prowess of a cat whereas the woman might find a cat's softness, seductiveness and sense of mystery something of a mirror held up to her own good self.

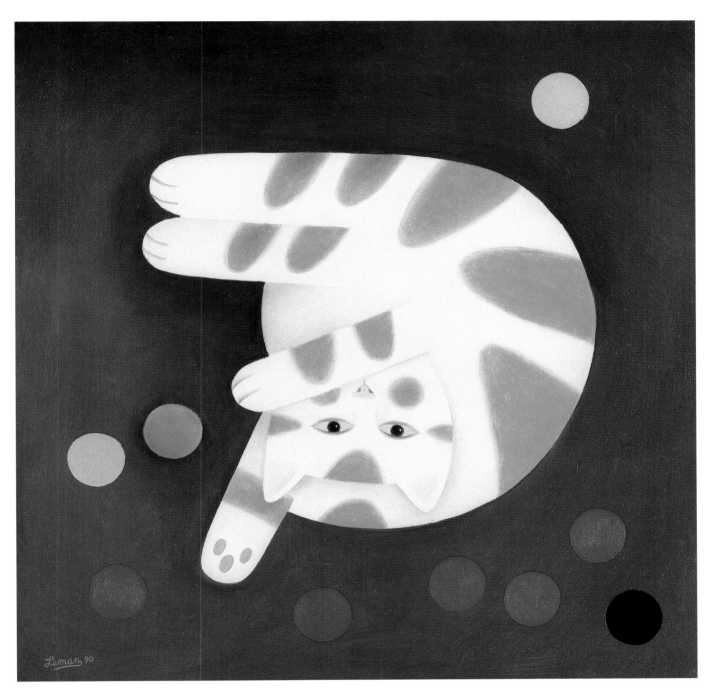

'Henry' from Curiouser and Curiouser Cats
Oil on board, 1990
30 x 30 cm
Private collection

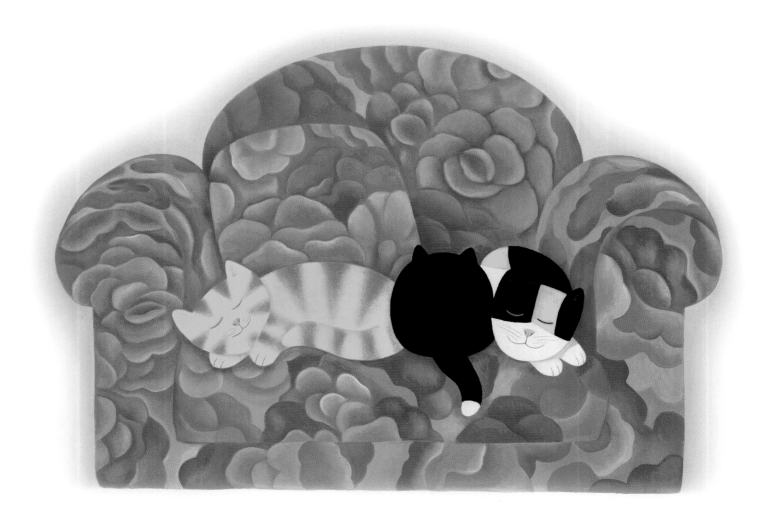

Painting from Sleepy Kittens
1993
Private collection

Advertisers have similarly dismantled the essence – or rather, all the essences of the cat to make it as useful as possible to their needs. Choosing the natural associations of the cat from plush softness (bathroom tissues) to strident agility (cars), cleanliness (soaps and medicine) to healthy appetites and long life (cat food, naturally), the cat finds its way into many applications – one might add also, a certain business telephone directory. There is a famous image of a fur-clad model cradling a dusky camera attentive cat to promote the idea of the necessary luxury of a mink coat. A curious irony, perhaps? Actually it wasn't so long ago that cat fur was regularly substituted for mink in trims and collars for, shall we say those who were less well heeled or plain undiscerning.

All these considerations must surely have impressed upon the mind of Martin Leman, whose experience in the world of commercial art is more than considerable. For those who create the imagery intended to sell the product, it is more than essential to find a subject which communicates directly and immediately. In the 1950's Dr. Ernest Dichter wrote 'The Strategy of Desire', an early, and indeed erudite, attempt to quantify and explain how one could make people desire products they did not know they even wanted. Key imagery was – and of course still is – crucial to this concept. In fact, perhaps it is more crucial than ever before because we are more visually literate than ever before.

Cats have been used in advertising since practically the start of the industry itself, around the late nineteenth century, a logical development perhaps, of the animal's appearance in works of art as symbolic and narrative devices. In the latter instance, they might have been used to convey part of an idea or thought. In the former, they are suggestive of an immediate, encapsulated thought. It might also be stated here that the mid to late Victorian period was one where an interest in animals and a fascination of novelty went hand in hand. This is the grand age of the increasingly

mass produced automata machines, mechanical piano and puppet theatres for domestic environments. This is of course the pretelevisual age (admittedly only 100 years behind) but the need for entertainment was just as keen. To this add the 'televisual' possibilities of thevitrine glass box trophy cases – but not featuring anything as simple as the rarest or heaviest.

Taxidermy had reached its height in both craftsmanship and idea. These particular vitrines contained the curious and the impossible – stuffed creatures (often cats) with extra heads, limbs, tails – the attempt to show the monstrosities of nature – the disfigured runts and hideous deformities or multiplicities. The late Victorian period of course, abounded in sideshows and freak shows. John Merrick, the 'Elephant Man' was a figure of fascination and penny-a-time fun. Stuffing animals – cats, dogs and other familiar creatures – and presenting them either as laboratory specimens or more fancifully in minute human costume and in human attitudes was quite popular for many decades. (The birth of kitsch, perhaps?) Whether the subject encased in glass was a genuine unfortunate of nature of not, was not the point; to feed a fascination was. The plentiful nature of unwanted domestic animals being such, it is not surprising to find several examples surviving to this day. Freaks of nature in the animal world are rare and certainly those which are born as such, rarely survive past a few days, so necessity becomes the mother of compulsion too.

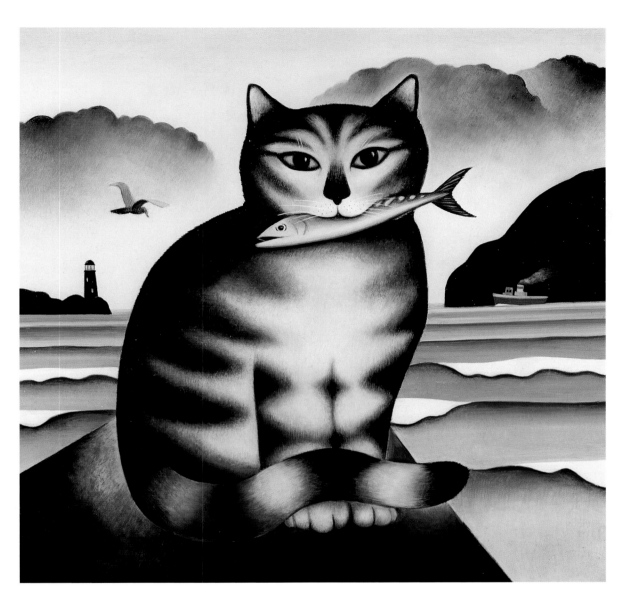

Painting from Comic and Curious Cats
Oil on board, 1979
30 x 30 cm
Private collection

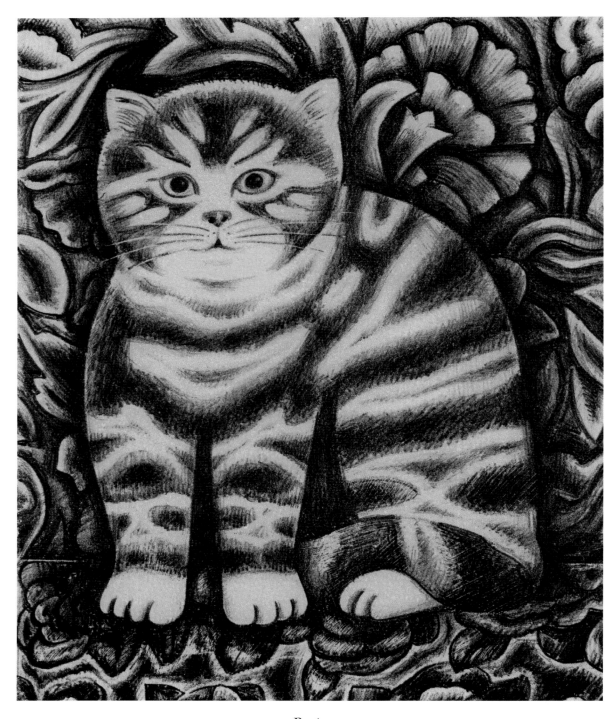

Rosie
Litho, 1983
21 x 19 cm
Private collection

Naive art has always, for some, been a rather curious term. In essence it means 'artless' – in other words without guile and complication or affectation, as opposed, of course to lacking any artistic merit. But there are other definitions which might throw a more particular and useful light on the whole subject and reason. Naive art can also be unconsciously and amusingly simple – un-complicated, direct and sometimes even a little childlike in its concept but rarely in its technical merit. The naive artist often retains that experimental and discovery-wonder of a child but is a supreme craftsman. In the world of art in general, it is something of a cardinal sin to suggest lightness and abandon. Irony is worshipped at most altars and prized because it is divisive and selective in whom it allows to worship there. Also another point is that if art is too accessible it surely must lose its mystique and therefore its value in both aesthetic and commercial terms.

Even Picasso – no naive artist he – was at a young age able to paint like a master but acknowledged that it took his whole life to learn how to paint as a child. Martin Leman knows very well the considerable antipathy to naive art in general. For some it is too close to the world of craft and utility to be considered intellectual. If something is humorous can it really be intelligent, is the question on many observers lips. Many artists who have been through the portals of the Portal Gallery in its long history of championing this kind of art in particular will be more than familiar with this artistic arrogance and antagonism. And yet, they will also very well appreciate those who positively love, enjoy and significantly collect such work.

Leman's cats share a good deal with those early wood cuts, engravings and drawings rendered in a typically haphazard and 'folksy' way – those illustrations and art works particularly of say, the sixteenth and seventeenth centuries. There is the same flatness, the same child-like innocence, often a blurring of scale and a humorous imperfection. These early works, mostly anonymous, of course might be described as naive, in their simple directness and definite lack of guile – but not of purpose.

American folk art brilliantly exemplifies the quintessence of the naive and with the tradition of quilts, tapestries and other country needlework pursuits (many of them having direct links with the Mayflower legacy and remnants of Old England) the connections are clear indeed.

Another related element of this sort of art which can often be seen in Leman's work, is stylisation. In terms of artistic representation stylisation simply means conforming to the rules of a conventional style. There is also the same flatness or two-dimensional quality seen in so much strictly naive work. But another curious paradox about stylised art is that it is at once very real and absolutely impossible. There is a conscious idealization – like for example, the stylised sculptural lines of the silver Jaguar motif atop the bonnet of the car of the same name. Look at a typical Art Deco clock – the classic marble and chrome examples, which often have a Flapper holding the reins of lithe and lean panthers or leopards. The clock itself is almost incidental. It is all too factory-perfect, architectural and ideal. It represents the modernist preoccupation of the age – not necessarily its reality. Leman's cats similarly may have been portrait commissions, dreamt up from memory or simply invented – but most, if they are not truly representational, share this strange quality of being very tangible and total fantasy too.

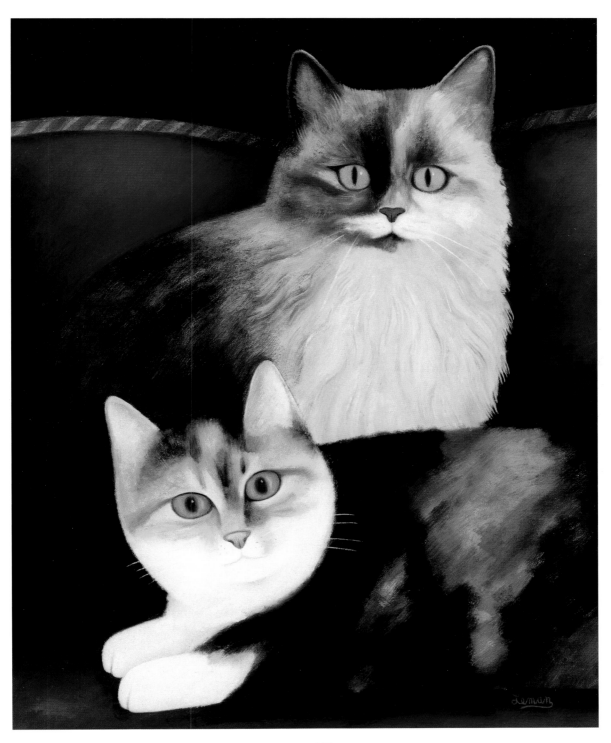

Honey and Fancy
Oil on board, 1998
30 x 25 cms
Private Collection

But whilst Leman and his collectors and critics may agree that he is a naive artist, he had a thorough artistic training. In fact he has been described as the most 'sophisticated' of naive artists. His work as graphic designer, typographer, art director, teacher and magazine producer opened up several artistic avenues demanding different skills and disciplines. Hence when one examines his entire oeuvre it is almost baffling to witness just how many styles Leman is able to work in. From the perfectly painterly to the willing naivety of his beloved cats, Leman demonstrates a broad range indeed. Another term 'primitive' has also been ascribed to Leman. In essence, primitivism refers to a specific time in art history, that is, the period before the Renaissance – the rebirth of classical antiquity as an art inspiration. Primitive also refers to an artist who is untutored and approaches his work in a naive way. So, technically, Leman cannot be described as primitive, even though he may display primitive devices in some of his work.

Today, primitivism seems to find several outlets, most obviously perhaps in the Stuckist School. The appeal of direct and untutored and therefore, in some minds, unshackled thought is certainly considerable. It is akin to being part of an aesthetic revolution. Like the Imagist poets who felt that the first thing written down when composing should stand without revision or those who created Dadaist or Art Brut work there is clearly a 'devil may care' immediacy at work. Leman's prolific nature, his speed and near obsession with his cats shares some elements of these creators.

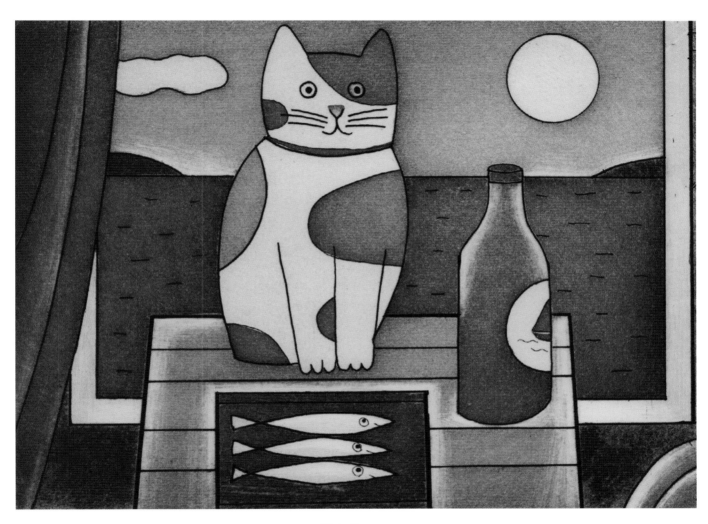

Fish Supper
Etching, 1994
Private Collection

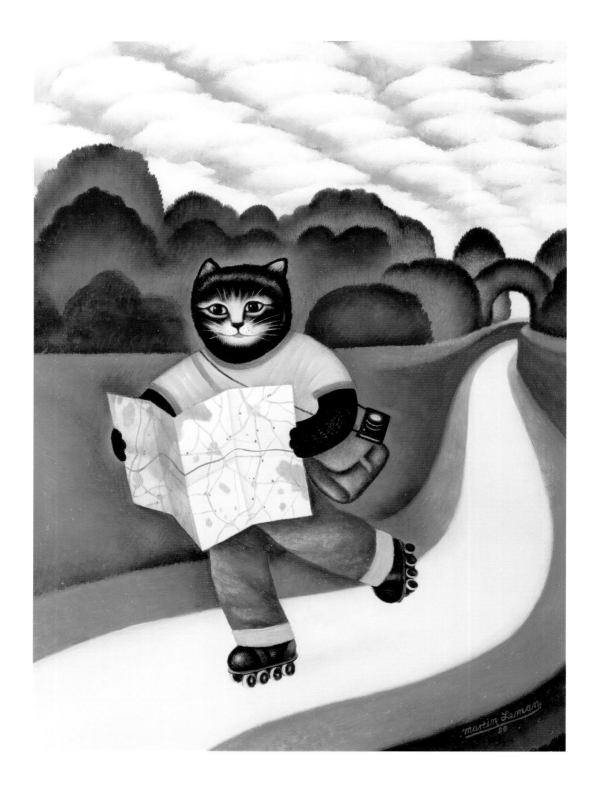

Martin Leman's interest in naive art extends to an appreciation of others' work too. In 1985, with Jill, his wife, Leman published 'A World of Their Own' which was a collection of their favourite-twentieth century British naive painters. By his own admission many might be limited in vision and technique but the intent is certainly sincere. In almost all there is that sense of wonder and magic, which tends to evaporate with seething age. And perhaps this is another reason why naive art in general might be frowned upon by many. When one grows up, one puts away childish things – as a rule. To continue to be fascinated by fantasy and magic might not only seem inappropriate to some but might also issue them with a challenge they cannot answer. Perhaps it was the same sense of adventure, experimentation and fun, which led Leman to create Arcade, in the mid 1960's, his magazine celebrating popular culture and filled with familiar and peculiar illustrations. Short-lived though it was, it certainly stood as one of the fizzy, original publications of the time along with other publication hits such as Private Eye and Oz.

Painting from Starcats
1980
Private Collection

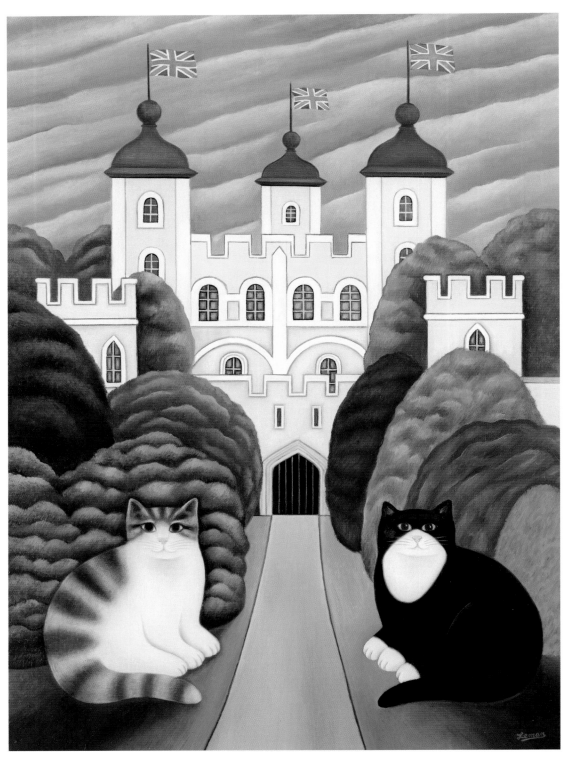

Tower of London
Oil on Board, 1976
Private collection

In several varied and unusual ways, Leman betrays his admiration (which seems curiously conspiratorial). His styles range from the classic to the comic, the plainly humorous to the wholly impossible – not lacking in humour because of that. Leman's cats possess character, knowing, style, and more often than not, an assured authority.

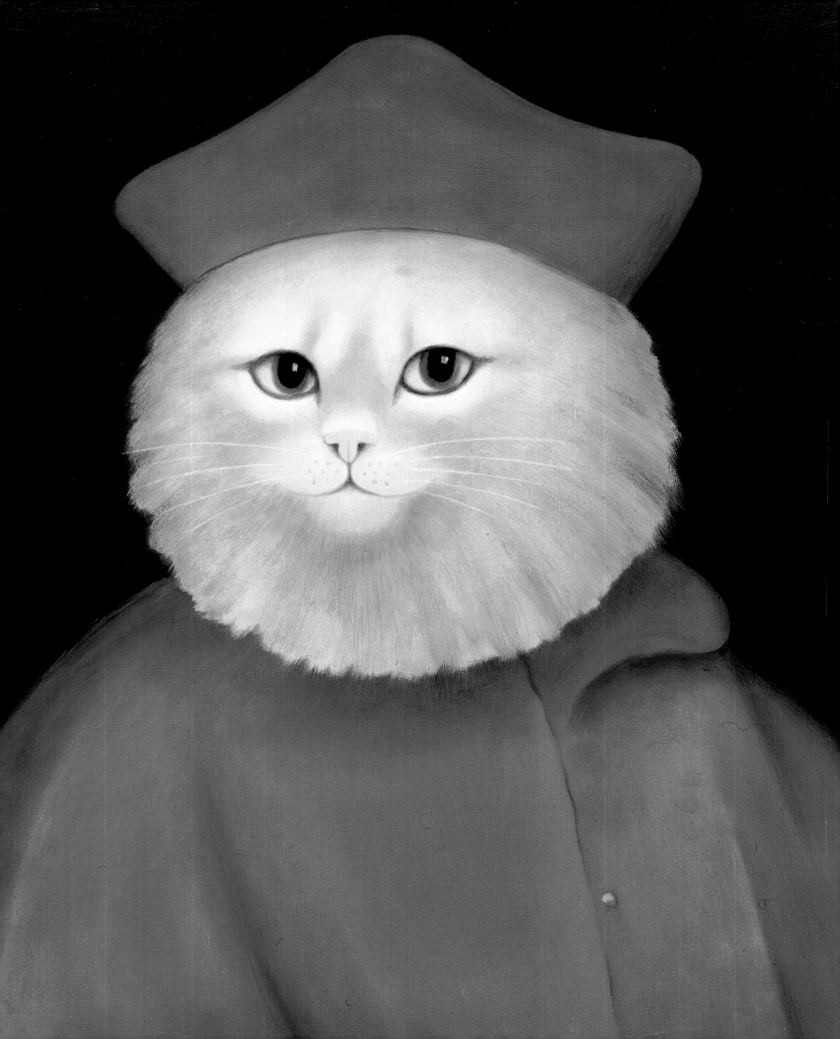

Chapter 1
Cats in Clothes

For I will consider my Cat Jeoffrey

For he is the servant of the Living God

duly and daily serving him.

Christopher Smart

HUMAN KIND HAS always been fascinated with creating life. Not simply the life that springs from its own loins but a sort of 'artificial life' as represented by such devices generally falling under the title of Automata. In the main (although being several thousand years old in concept) it was the eighteenth century, which saw a huge surge of interest in the making of these 'life forms', which would spin and perform at the turn of a key. Clockwork representing coiled energy on a spring – animated life – and it was almost a magical device then and not just reserved for the powering of the hands of a clock or the tone of a leaden chime.

Many of these figures were naturally human – jesters, minstrels, clowns, dancing girls – but so many others were animals. And more than that. The creatures represented, sometimes stuffed realities or specially made toys, were clothed and placed in everyday human situations, playing instruments, dancing or wearing clothes in tableau vivant glass boxes – drawing room curios and perhaps the first 'televisions'.

The Bishop
Oil on canvas, 2002
90 x 76cm
Private collection

There was a positive mania to dress up one's pets. In much the same way that today, there is a desire to put them into a Burberry check raincoat, cashmere roll neck or smart Gucci collar. Cats were just as much 'raw material' for automotive inspiration as any other creature – maybe more so because of their undeniable domestic connections.

Martin Leman's humanized cats are certainly in the tradition of clockwork, stuffed, manipulated or painted cats of the past. Their human attitudes and clothes provoke humour of the blatant or knowingly wry variety. The very way he paints them, with such precision and care points to Leman's tangible enjoyment in such depiction.

When speaking of this style of cat portraiture, it is impossible for Leman to suppress a mischievous and knowing smile. Choosing carefully the type of cat, the exact colouration and most importantly, the facial expression, the clothing overlaid, enhances the undeniable character within...

The Captain
2002
41 x 31 cm
Private collection

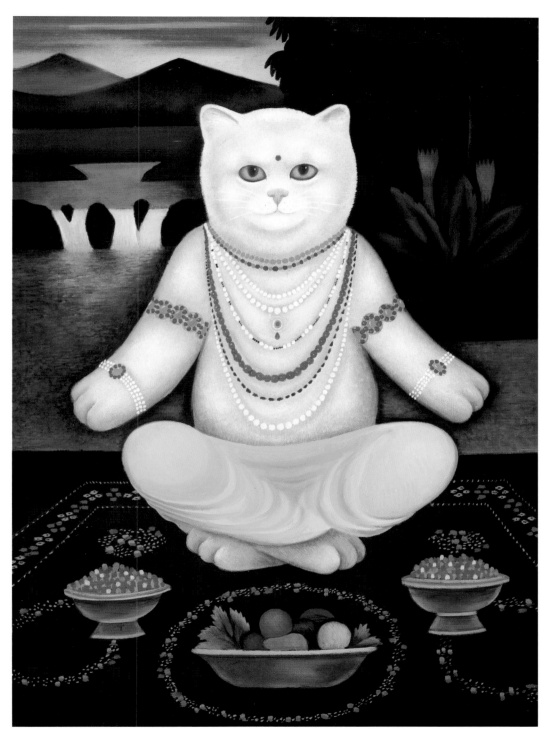

Painting from Starcats
Oil on board, 1980
Private Collection

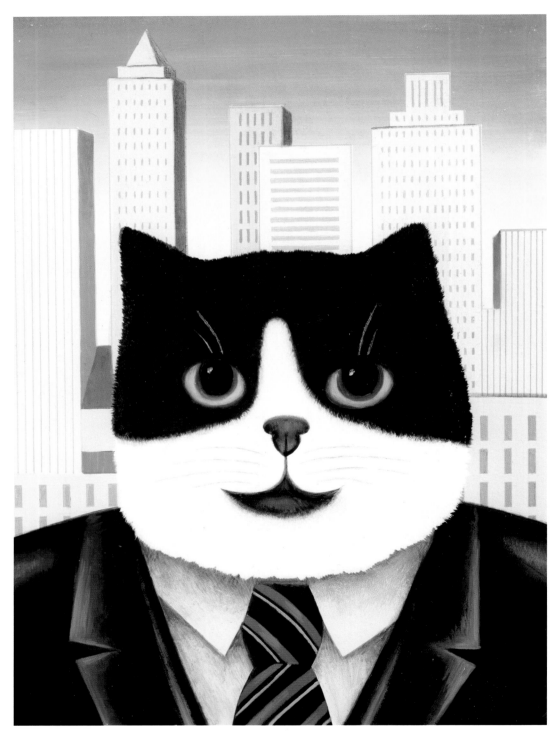

New York
Oil on Board, 1975
Private collection

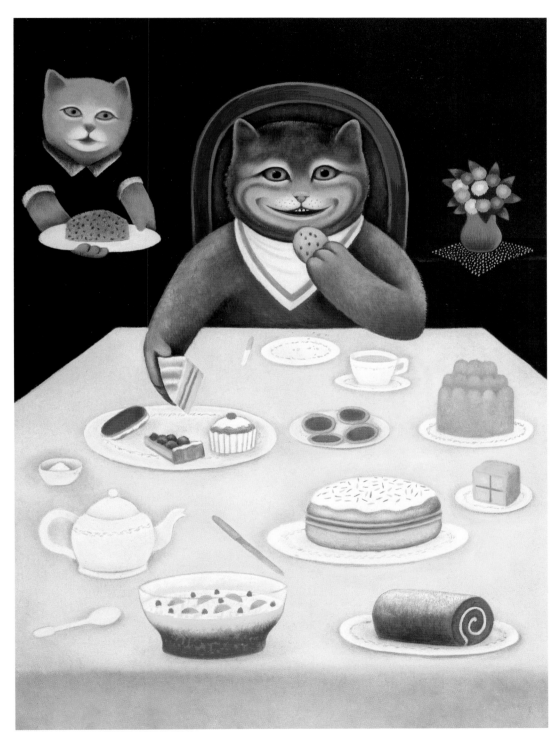

Painting from Starcats
Oil on board, 1980
Private collection

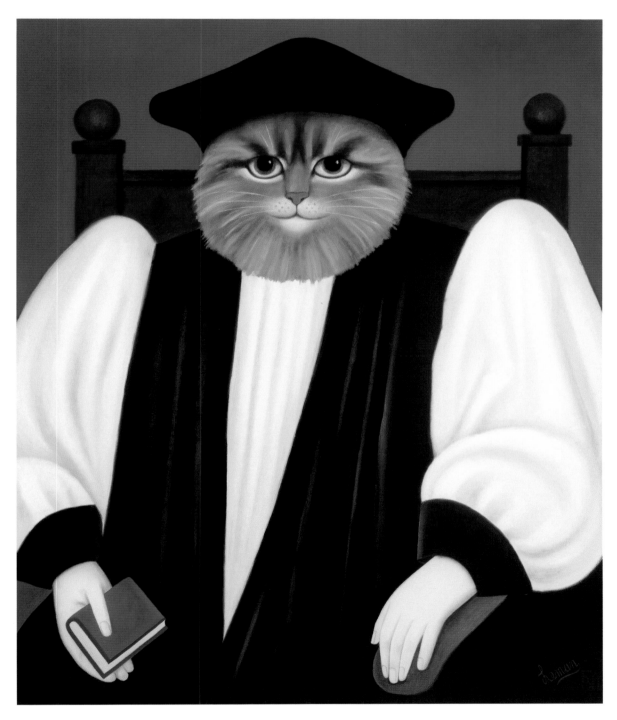

The Bishop
Oil on canvas, 2002
90 x 76cm
Private collection

Left: Painting from Starcats
Oil on board, 1980
Private collection

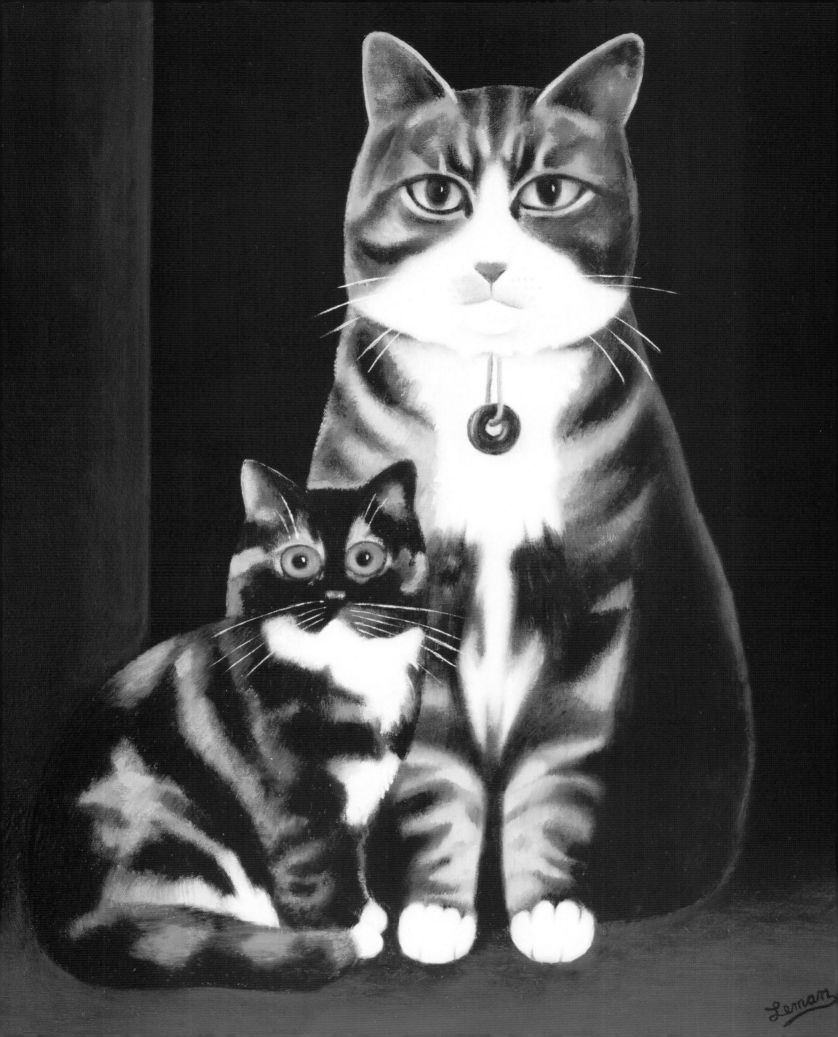

Chapter 2
Portraits and Commissions

Pussy cat, pussy cat, will'st though be mine?

Thou shalt neither wash dishes nor feed the swine

From a popular children's nursery rhyme

CATS HAVE BEEN a natural subject for artists for thousands of years. Long before domestication, surely the power and prowess of the 'big cats' – tigers, lions, panthers was noted and held in awe. From tomb paintings to the latest photography images, they lend their feline elegance to the inspirations of the creator. Capturing them unawares, in action or perhaps merely as an interesting or symbolically significant element of an overall design is perhaps what one imagines when thinking of cats in art.

Gericault's cat 'Chat Blanc' is depicted asleep, yet curiously aware by the neo-prone body language so familiar to all cat lovers and observers. Even in sleep, cats appear ready for anything. Picasso, who famously, and for some, controversially enjoyed the blood bath spectacle of the bullfight, paints an image of a vicious teeth-baring, chicken-carrying hunter. The gentler, more fanciful Chagall in his 'Paris par la fenetre' poses a symbolically human example of a cat profiled against the backdrop of the Eiffel Tower. But portraits of cats, that is in most cases where the subject is 'aware' of being such are relatively rare.

Meg and Pelusa
Oil on board, 2000
12 x 10 cm
Private collection

Martin Leman, by his own admission wants to give his sitters 'an icon-like presence.' And looking at most of his work in this category, it seems that he has achieved just this. Of course, the slow, steady gaze of most cats and their quiet, considered way of performing, make them ideal subjects for portraiture. Their eyes are compelling, not immediately comprehensible. There must be, we feel, oceans of thought behind them. The natural sculptural lines, gradations of colour and pattern or indeed dramatic single hue are perfect for reinterpreting by artists. Leman comments, 'Cats are beautiful creatures and give their owner constant visual pleasure. The painted portrait should do the same.'

In the past, though far much less today, the commissioning of a portrait was not only a commemoration of the sitter. It was in plain parlance, the most visually tangible sign that one had 'made it'. After all, it is not the norm to see portraits of comparative nobodies. A portrait is committed to canvas – ostensibly for all time. At least that is the original intention.

In any event, a portrait is a celebration of a life and when one applies this impetus and action to the commissioning of a portrait of a favourite cat, the intent is precisely the same. The celebrated French author, Colette, who wrote about her cats in her books, was clearly passionate about them. Her pen portraits convey some of the love and respect she felt for them. She once wrote, 'the only risk you ever run in befriending a cat is enriching yourself.' So convinced she must have been of this that she even posed for a photograph stretched like a sphinx on a glossily decked bed looking magnificently like a cross between a panther and Cleopatra – in that order. Of course, this was around the time of the second (and more mass conscious) Egyptian Revival when sphinx motifs, cat jewellery and the like were popular.

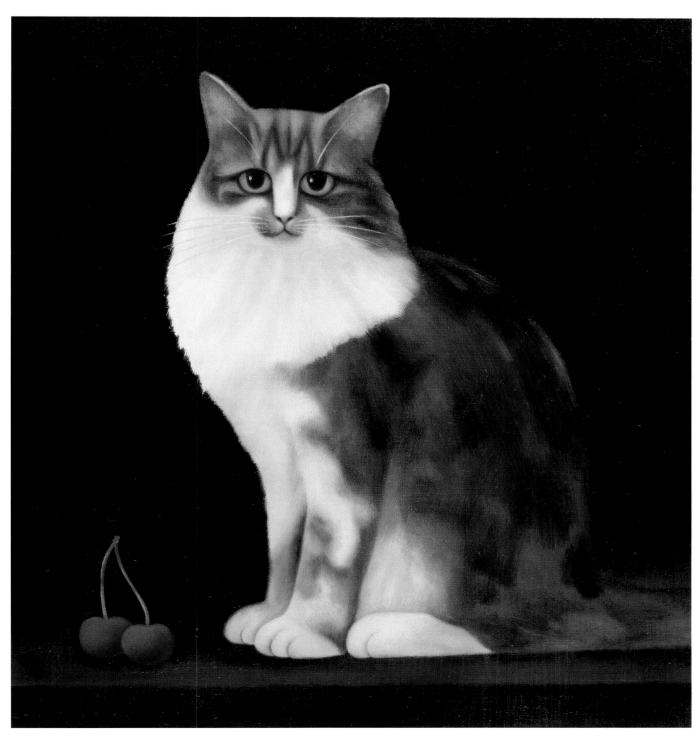

Amber
Oil on board, 1991
49 x 43cm
Private collection

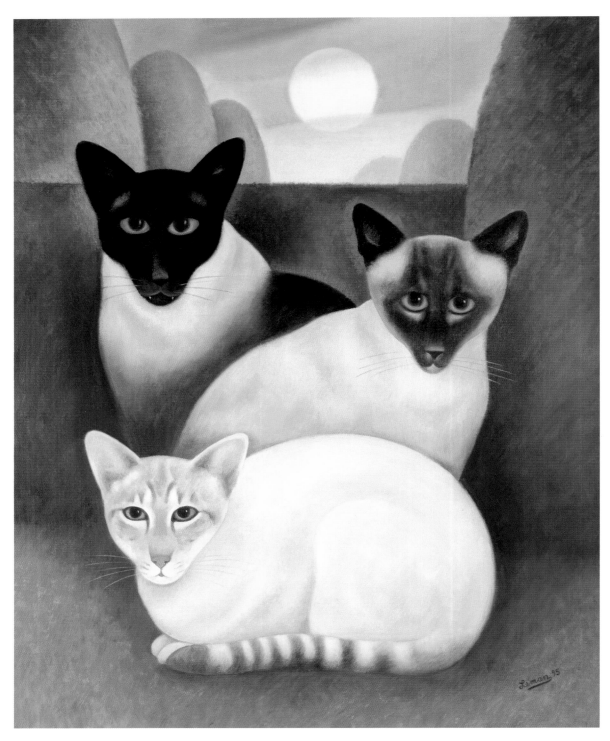

Sam, Kitty & Willow
Oil on board, 1995
30 x 25cm
Private collection

Whilst of course, it is quite possible to create a portrait without the direct eye contact of the sitter, it is perhaps reasonable to accept that most people comprehend a portrait as something one can literally come 'face to face' with. Engagement is everything. Eyes must meet eyes and whilst not risking the cliché about windows and souls, it must be owned that eyes are the chief clues to a personality. Invariably, Martin Leman's cat portraits all look out at the viewer with slow, steady, multifaceted and coloured gazes – slow and steady of course – their characters and hallmarks marked by an almost imperceptible widening here or a tactical narrowing, there. These are further emphasised by the depth, rotundity, hue and overall shape of the eyes, evincing extreme alertness, guarded passivity or a land somewhere in between.

For those who cannot see the lure of a cat or even have little love for them, they may recall that as a rose is a rose is a rose, a similar fate belongs to a cat. If all places are alike to a cat, can it truly be said that all cats are similar? For the seasoned cat lover, owner, serious breeder or armchair admirer via the thousands of feline tomes available, every cat has its distinct personality, temperament and peculiarities. More a case of no cats being alike to one another, perhaps?

When Leman is approached to create a portrait of a cat, he is faced with a challenge to make something ring true about the animal and especially its relation to its owner. Could it be a quirk – a favourite ball used as a visual or narrative device? Might it be an imperfection, like the little snippet of ear missing from one creature – the result of a feline scrap (or not being able to retreat quickly enough after feline congress, where, in most cases, the female delivers a sharp paw swing)? It is the little things which make portraiture personal and just as in human portraits, these cat portraits must convey a uniqueness.

To help in this task, Leman often makes the background relevant – literally placing the sitter in context. It might be, say, the owner's home or garden, which emphasises the actuality and connection between them both. But whatever device is employed, Leman believes strongly that a cat portrait is exactly that and not a painting of a cat. The animal has to have existed and been captured in a particular pose as opposed to simply rendering something similar from imagination. As he sifts through endless images of feline friends he gives a continuous running commentary about which could and could never be a 'portrait' and why.

Leman mainly works from photographs of his sitters, since cats are not happy to sit for too long, even though they are being virtually sanctified. Studying the movement, colour and form (and of course, any peculiarities, deformities and so on) comes next and all these help in the final presentation. But Leman is adamant that if for some reason – and to date this has never happened – that someone does not like what he creates, they do not have to have it. It will simply join the artist's racked-up cattery of other cat paintings.

Mickey, Smudge & Pudding
Oil on board, 1985
50 x 40 cm
Private collection

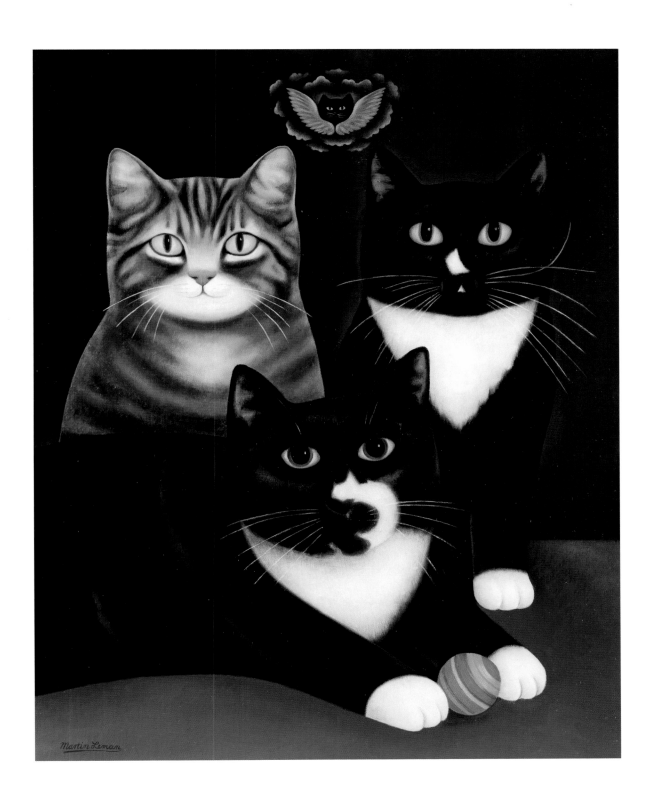

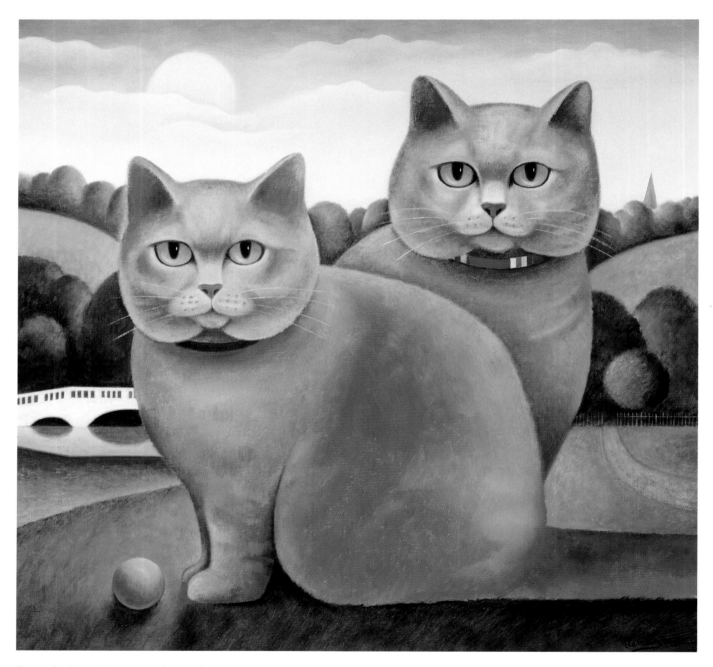

Puss & Puss/ Hampstead Heath
Oil on board, 1997
30 x 30 cm
Private collection

Right: Gloria
Oil on board, 1982
32 x 24 cm
Private collection

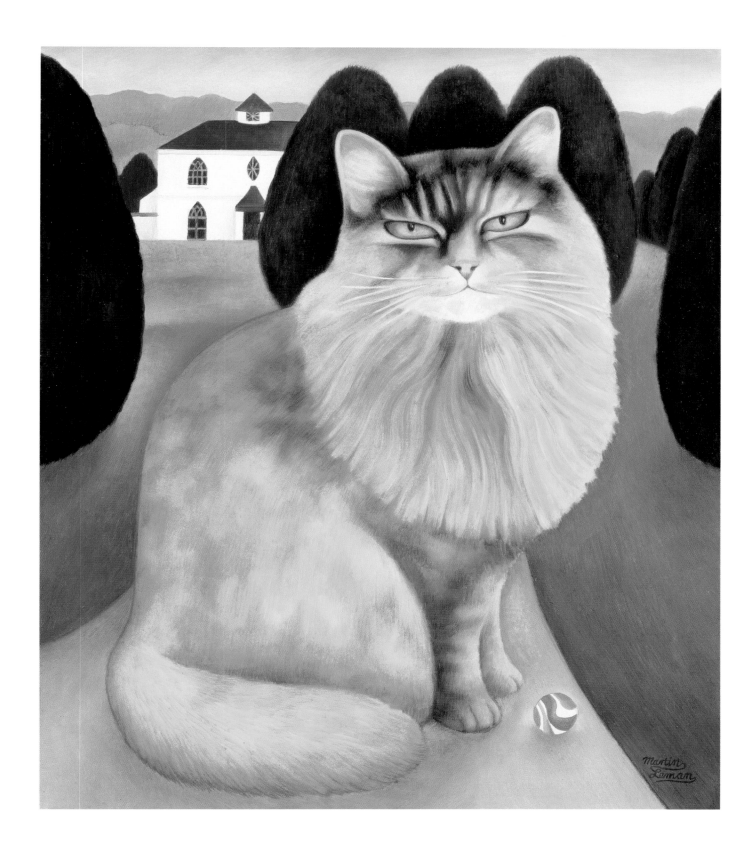

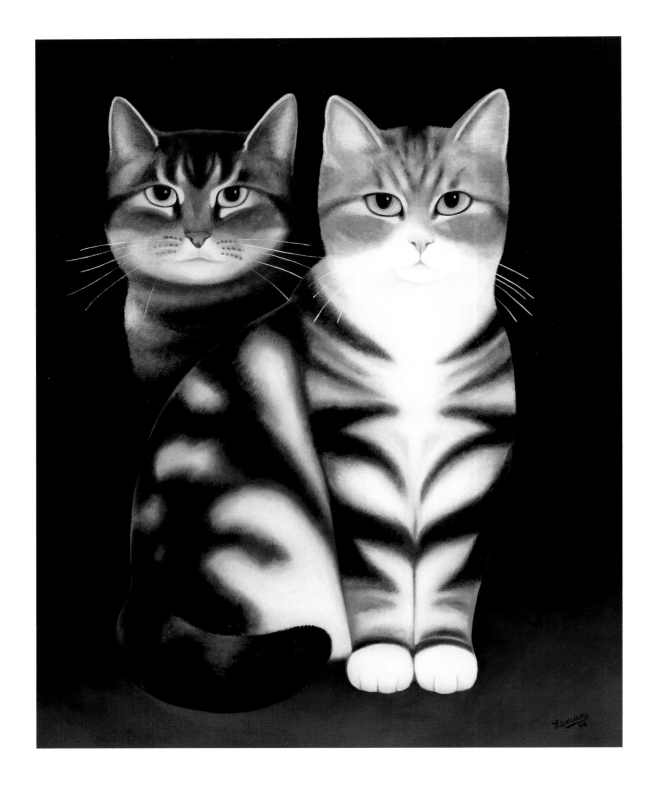

Humour is an enormous element of Leman's portraiture style. After all, these are or will be treasured souvenirs – if, as usually happens, the cat owner outlives his or her favourite friend. They are reminders, images that one day may spark a fond or even melancholic memory and prompt a nostalgic smile. 'I try to convey the essence of the cat with a sense of humour,' Leman opines. 'The design and choice of colours help communicate this.'

Leman began painting cat portraits in the early 1970's and some of these were used for greetings cards and posters and he created twelve paintings for Angela Carter's 'Comic and Curious Cats' published in 1979. His first commission goes back over thirty years – a triple portrait capturing 'Nat's Cats' for Natalie Gibson.

Of course, photography has today enabled almost everyone to become a chronicler of time, events and subjects. Indeed, Leman himself has produced a book of cat photography. The latest digital camera, whilst not being able to turn its user into a great photographer, still enables a degree of competence. But there is something about the capturing of the feline essence on canvas, which is tender, humorous, ironic, extravagant and time honoured all at once. A commission is something of a big step – or in cat terms, perhaps, an ambitious leap. A celluloid snap doesn't quite compare.

Stripes and Goldie
Oil on board, 1994
Private collection

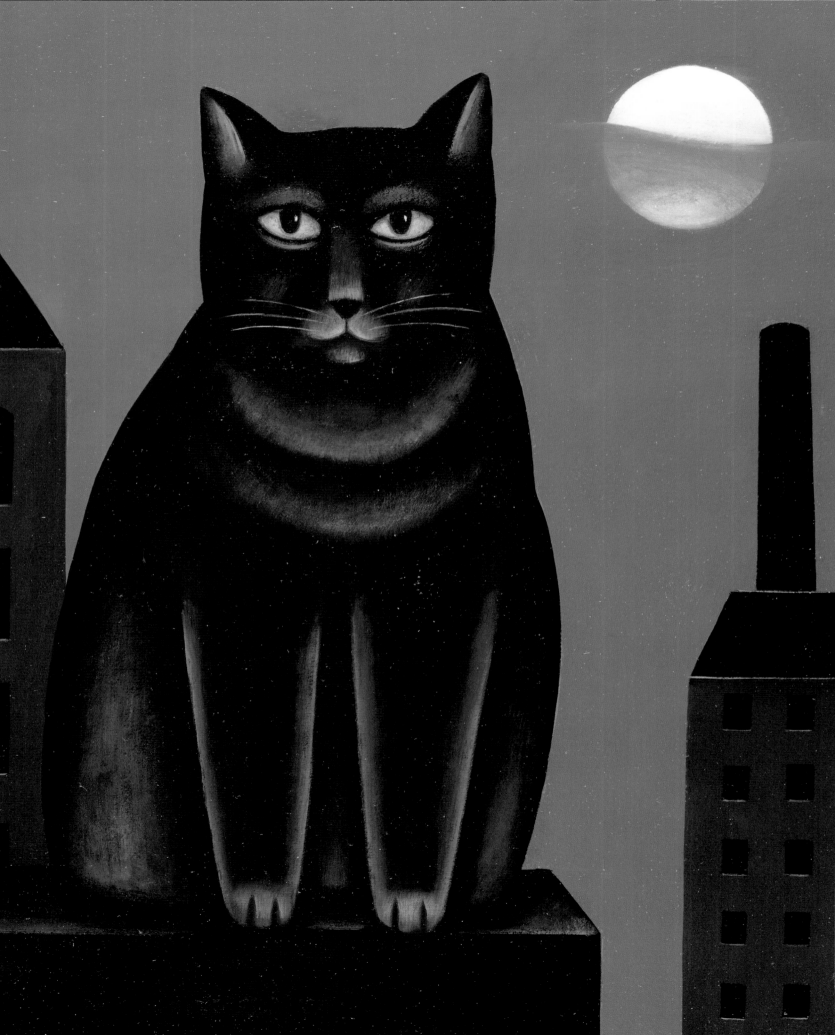

Chapter 3
Night

Strong, gentle cats

Majestic and beautiful.

They too, sit still

And feel the cold night air

Charles Baudelaire

CATS ARE NOT purely nocturnal – although for a lot of people they immediately convey that characteristic. It does remain the case though, that trap a cat indoors for the night and they are not happy – to say the least. Their lithe, sinuous (in the main) forms, the strident silhouette, petal-soft padded feet, speed and deliberate, considered stealth, all find ready connections with the dark, the half light, the moon and the shadows. Expressions abound concerning cats and night. And could one really think of the glamorous, muscular, sexy image of a night-time jewel thief being anything but a *cat* burglar?

Indeed there is a certain mystery and magic about cats which the ancients believed and which civilizations commemorated and worshipped. Probably one of the major tenets concerning these aspects was a cat's dogged sense of independence and self-possession. Dogs have owners – cats staff, goes the old saying and there is more than a ring of truth about it. For whilst a dog's tail lashes wildly in joy or hangs limp in guilt, the independent cat, even if he has stolen the cream and the tea time pilchard to boot is divinely confident with it.

Wesley
Oil on board, 1989
30 x 30 cm
Private collection

There has also almost from the very beginning been a sinister and secret quality associated with cats and the night. Indeed several very early engravings show images of the devil with an accompanying cat. Cats conspire and even melt into the dark and of course have been linked with witchcraft, as devil's familiars or friends. They have often taken the form of succubae – perhaps quite well founded because a number of unattended babies have been smothered by cats. Cruelty to cats because of these so-called associations has been immense. From the almost unthinkably ludicrous animal trials of the mediaeval period, through to the persecution of young or old women as sorceresses and peculiar customs such as drowning women accused as adulteresses with live cats as the point finale, the slate is spattered with feline blood.

Black cats were typically linked with the night, visually logical perhaps, but laughingly primitive. The presence of one close by could end with the owner being burnt at the stake – along with kitty.

Often cats provoke one of two reactions – at their simplest, love or loathing. Pope Leo XIII's favourite companion was his tabby, Micetto and Richelieu installed dozens of cats at court. But Napoleon – that fearless leader of men – broke into a cold sweat at the very sight of a kitten.

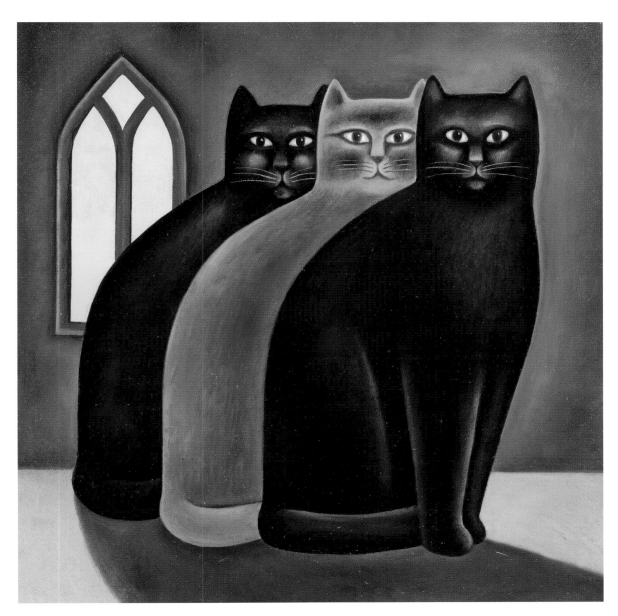

Albert, Archibald & Silas
Oil on board, 1998
30 x 30 cm
Private collection

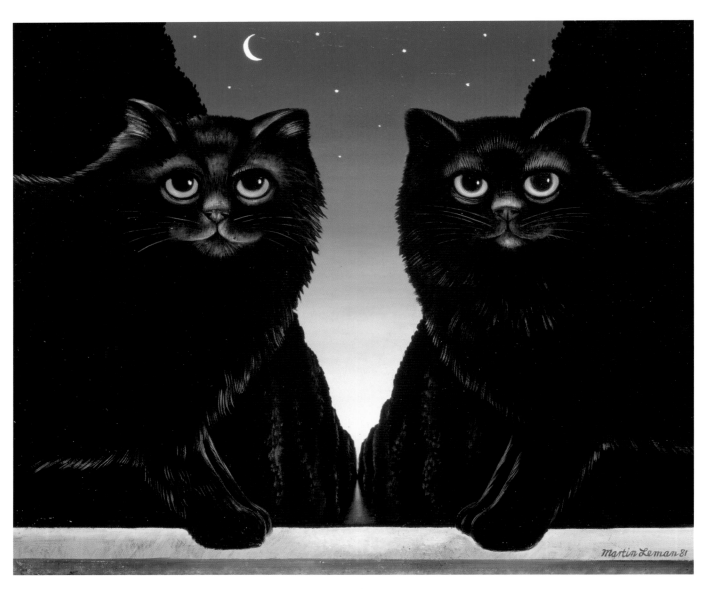

Dark
Oil on board, 1981
25 x 35 cm
Private collection

In all of Leman's images of cats at night, there is a certain quality that they share. The focus for the viewer inevitably becomes the eyes. Apparently cats possess the largest eyes of any mammal. In the varicoloured, sueded twilights and shaded darkness, their forms are distinct, their shapes almost cut out and pasted on nocturnal backdrops. And those eyes – anything from marmalade orange to jade green seem to shine and glister. In fact, cats' eyes do shine by night and have a totally different quality by day. Little wonder then that a number of quack cures or witchcraft spells for blindness involve blowing the ash of a ceremonially burnt cat's head into the eyes or some other horrific use of the eyes themselves.

The eye of a cat has the power also of adjusting focus to distance rapidly – another useful trick to have about them, as they encounter the darkness. Cats see much better than man in the dark and they have a binocular field vision of 120 degrees or so, compared to a dog's 83 degrees. They seem made for the night or perhaps, the best of both time spheres. They are equally content – whatever the hour.

Martin Leman loves to observe cats and to do so by night is a lesson in itself. He recalls one event very clearly. Coming downstairs one night to make sure if his cats, Pip and Kitty had come in through the cat flap, he encountered a brown Tom 'up to no good, I'm sure,' he remembers but totally the master of the scene. 'He was surveying the house, much like an estate agent would – and then he took off and left.'

The confidence of the cat by night only leads to one conclusion that the night is a natural ally. It will provide cover and a place to escape into. It will also provide a varied and rich menu, a la carte, of more deliberately nocturnal sweetmeat creatures for dalliance or devouring.

'A cat is a sexy vehicle to me, to convey a feeling', admits Leman. 'For me, they are a little bit like pin ups – ultimately quite sensual.' (Even so, one cannot quite imagine the artist concealing behind the door of his army locker in Egypt one of these pussies.)

But once again it is the unpredictability that often comes with the night that gives rise to a certain sensuality and the cat associated with dense, impacted fur – even if it isn't the double plush Russian Blue that can be stroked two ways – conspiring with icy stars and a marble moon.

In some of Leman's night cat pictures, there is a definite sense of the surreal. Also, the lack of light means that there can be no doubt that they delight in centre staging. A curious surreal quality is evinced by some and of course, the famous, dry Leman humour is to be found in others. 'Peaceful Evening' for example, shows four cats – almost part of the landscape gardening scheme, suggesting that the viewer has disturbed them from some mischief. An owl – its eyes directly contrasting with the four feline pairs shines out a little alarmingly from one of the bushes.

The whimsical 'Moonlit' shows a content creature with something of the Cheshire, with its curiously insistent smile against a backdrop of magical, pinprick stars.

When one thinks of cats and the night, it would not be unreasonable to associate feral cats with this time. A feral cat is a domestic cat that has returned to living in a wild state as well as a cat that has never had a home, as such. Arguably, these wilder, often more ferocious, yet ironically shyer cousins of the window sill, blanket-basket moggy needs the cover of darkness to hunt and protect litters.

Naturally enough, the moon features prominently in Martin Leman's night cat images, almost as if to suggest there might be a direct connection between them – as opposed to the more obvious symbolism. Indeed, the moon affects tides and it is a well-known myth that you can tell the tide from the size of a cat's pupils.

Whether true or not, these stories and many others from around the world have lasted down the ages and continue to persist even today and the time immemorial image of the solitary cat at night and something vaguely intangible, hugely impressive and perhaps a little – just a little unsettling – remains familiar.

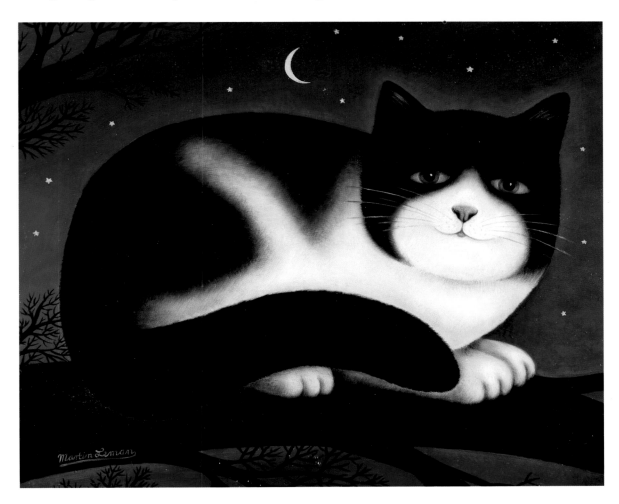

Jack
Oil on board, 1991
30cm x 30 cm
Private collection

Right: New Moon
Oil on board, 1988
40 x 30 cm
Private collection

Chapter 4
Kittens

There is no more intrepid explorer than a kitten.

Jules Champfleury

ARGUABLY, IT IS through kittens that children often learn at first hand about nature, nurture and eventual demise. As a first pet – and a familiar form, from nursery rhyme favourites and lavish fairy tale pages – the kitten has firm associations from the earliest age. Most kittens tend to be playful, inquisitive, utterly adorable and until relatively late, in their young lives, a mite unsteady on their eventually faultless feet. In fact, most young animals share in this first charming tentativeness and some experts have highlighted this as a sort of defence mechanism. One might say the same of human babies with their flattened faces and shaky air of vulnerability.

Undeniably, a kitten has a certain appeal that might call out or remind us of our own sense of fun and mischief. In Martin Leman's images of kittens, we see several distinct styles – almost as if that very playful nature of the kitten per se gives rise to the need for variety in depiction. They are as experimental in this depiction as a kitten is in its exploratory character.

On the Beach
Oil on board, 2003
Collection of John Maxwell

'He's nothing much but fur,' runs Eleanor Farjeon's opening line of her poem, 'A Kitten' and how true that is. A ball of mischief is how Leman chooses to depict these creatures in the main and it is with kittens that, perhaps, one can see a most definite connection with the human world.

Kittens do get into scrapes. Is not the mewing sprite up a tree just a little akin to the child with his head between railings? Kittens do peculiar things – though motivated by greed and curiosity – for example attempt to get into a jug of milk to lap up at least a mouthful before jug, cat and milk come crashing to the floor. Thus, Leman, with perhaps similar inspirations has a snowy white emerging from a ceramic kitchen jar and another, taking its repose in an old, partially unlaced foundry boot. Newly born kittens weigh only about two to five ounces and are some four to six inches long. So, the emphasis on the Queen or 'Dam' (their mother) is not only pronounced but also vital. A kitten's eyes will open only when they are between five to ten days old and will take up to three weeks to open to full feline rotundity. But however old a cat becomes, it is often generically and familiarly, simply, 'kitty', 'Catty' one might say, sounds ridiculous, inappropriate and anyway, is more clearly applied to certain humans.

Martin Leman's range of styles includes the resolutely illustrative to the neo-realistic. Often, as in 'Claudius', page 86, there is a comic impossibility artistic licence. At others, he poses his subject in unfamiliar or familiar situations which give rise to a certain recognition or amusement as in 'Christmas', opposite, he depicts a kitten, complete with Christmas party hat, surveying a table of goodies, much as an expectant child would. Whimsy might be an unkind word to attribute to this style of art but certainly there is a certain knowing kitsch and gentle charm.

Christmas
Oil on board, 1980
40 x 30 cm
Private collection

Home Sweet Home
Oil on board, 1986
30 x 20cm
Private collection

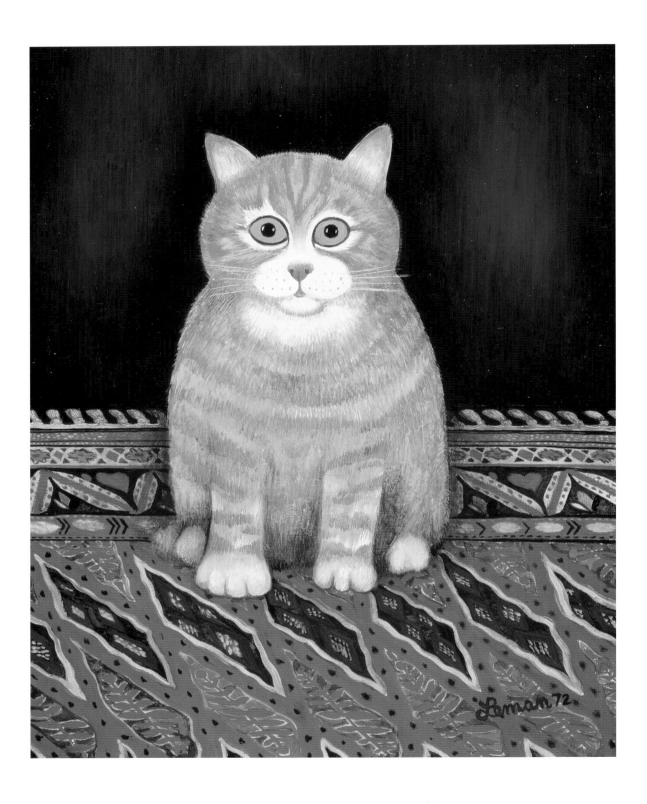

Again, the humanizing factor is the key. But it is also quite the case that the inquisitive nature of a very young cat will lead it into all sorts of amusing scrapes and deadly danger. Curiosity, after all, famously killed the cat. In reality, it must have done for many more kittens. The story of the 'gentlest Selima' stalking a collection of tender goldfish only to join them forever, cannot exist solely in the lines of a celebrated poem.

Understandably, Leman might be accused by some of ploughing a somewhat sentimental furrow – often with titles to boot, such as, 'Home Sweet Home', 'Blue Eyes', and 'Valentine'. In the case of the last, a heart-shaped box device sits at our endearing subject's paws. One supposes that Leman makes no apology for deliberately entertaining the endearing. Bordering on the kitsch to some and whimsy to others (indeed half close your eyes and one may even recall candyfloss style Victorian greetings cards), works like these have found and continue to find a ready audience. Could kittens be depicted any other way than playful, unsure, innocent, needing protection and yes, why not, cute? Anything so reliant on its mother for so long retains that vulnerability. A kitten cannot be cunning or vindictive. It has those things to look forward to when it grows up and kitty does indeed become, in nature at least, catty.

Cat on Mat
Oil on board, 1972
20 x 13 cm
Private collection

'At one of my early exhibitions, I had a small painting of a kitten sitting on a Persian carpet,' (page 78) reminisces the artist. 'This proved to be a very popular image – and that was the beginning of the many paintings of cats I have done over the past thirty years.' In those thirty years, over 26 books have been produced, he has staged more than 20 one-man shows, and made several appearances at the Royal Academy Summer Exhibitions.

Kittens – endearingly and eternally attractive have remained a human fixation, as we see in their soft-pad comic experimentation, endless inspiration. And although they all too quickly, for some, grow up and into tactical sophistication and in most cases, cruelly natural predation, the first few months of their lives remain an indelible memory. As the poet and one-time Laureate, Robert Southey, so perfectly penned – 'A kitten is in the animal world what a rosebud is in the garden.' (By all accounts – no thorns, yet). His praise of this creature is more than implicit and certainly, even a touch romantic. Might this be understood a little more when one realises the special relationship Southey had with his cat? This specimen rejoiced in the name of The Most Noble the Archduke Rumpelstizchen, Marquis Macbum, Earle Tomemange, Baron Raticide, Waowler and Skaratchi – shortened (curiously) to plain Rumpel. When the creature passed on, the whole household was required to go into mourning. And that included the no doubt bemused and perhaps, less than amused, servants.

Overleaf: Twins
Oil on board
30 x 40cm
Private collection

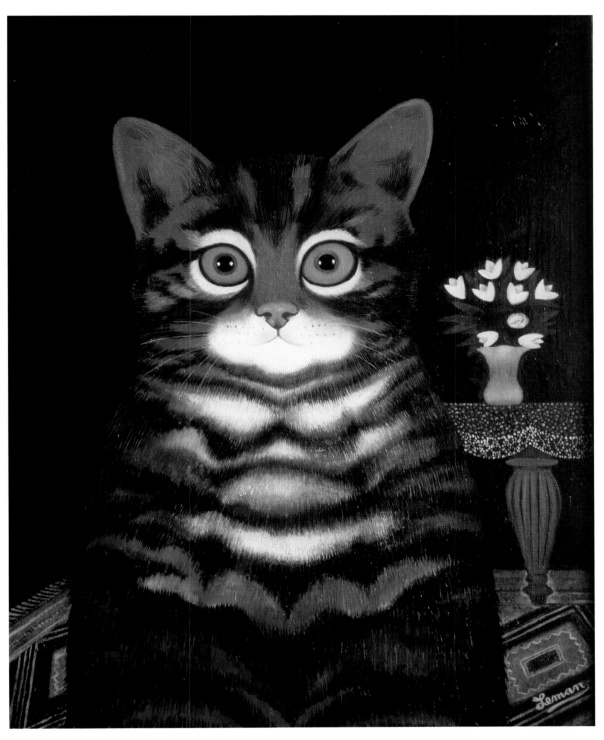

Blue Eyes
Oil on board
30 x 40 cm
Private collection

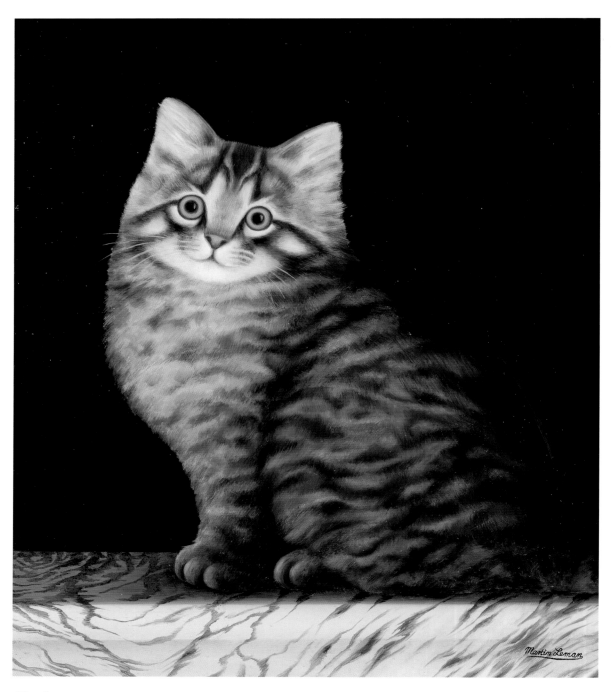

Claudius
Oil on board, 1982
30 x 20 cm
Private collection

Right: First Christmas
Oil on board, 1985
30 x 20 cm
Private collection

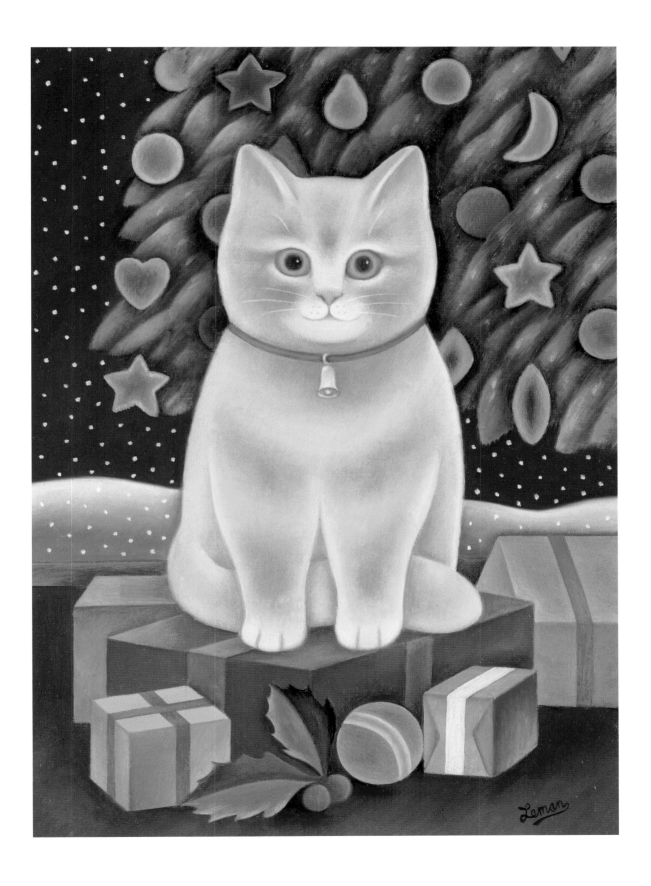

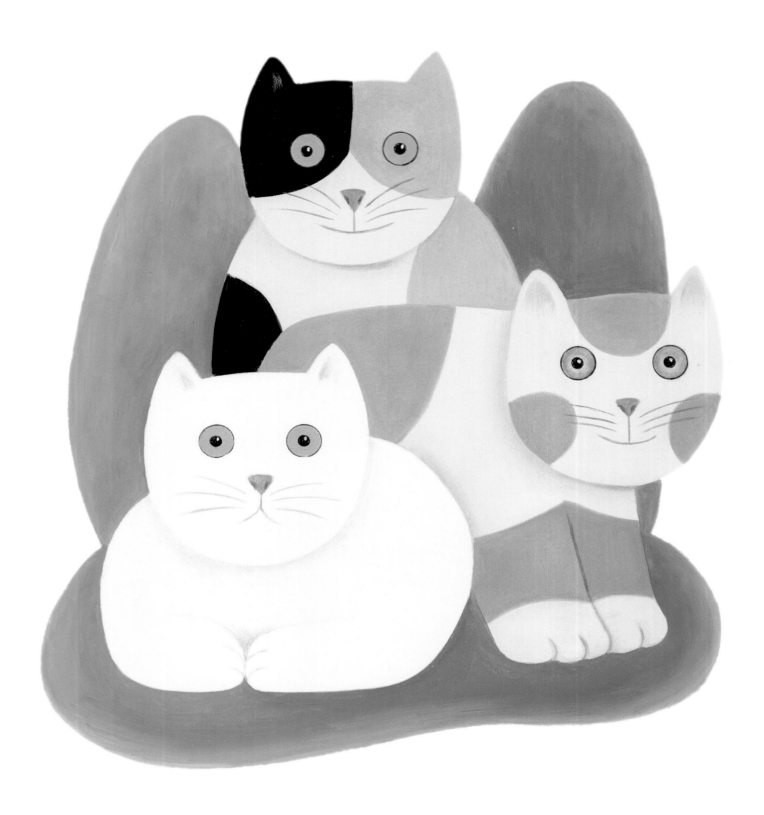

Chapter 5
Children's Books

'Well! I've often seen a cat without a grin,' thought Alice,

'but a grin without a cat! It's the most curious thing I ever saw in my life!'

From 'Alice's Adventures in Wonderland'

By Lewis Carroll

CATS HAVE ALWAYS been popular subjects for children's books, by way of illustration and of course feature significantly in fairy tales, pantomimes, nursery rhymes and dare one say it, even cautionary tales? Alice herself says that the most curious thing she ever saw was a grin without a cat. And everyone knows what curiosity did to the archetypal cat. So perhaps that is why he himself, doesn't question the upturned lips.

And also, because of their domestic familiarity, cats seem to triumph over the seeming ubiquity of the dog and are more tangible for that. In most illustrated alphabets for children, 'C' is almost always for 'cat' as indeed 'D' is for 'dog' but it has to be said that it is the cat, which because it is simple to keep in the main, that comes and goes as it pleases, is scrupulously clean and determined to remain so, that it was welcomed as a first, low maintenance pet. What could be better? A creature that is a very adornment and yet, makes itself scarce as well – of course, only to return.

Painting from Ten Little Pussy Cats
1995
Collection of Terry Price

Louis Wain is a celebrated name in the world of illustration in general and cat imagery in particular. He created 'Catland' – a hugely important and influential series of paintings of the said creatures engaged in very human activities. These were published from the late 19th century to the 1920's and certainly in their forward-looking animation style, variety and comedic possibilities, may well be said to have provided at the very least, an inspiration if not a template for the later and arguably, more successful stars of mass audience celluloid addicts who flocked to see their shaky heroes such as Felix, Sylvester and of course, Jerry's on-off friend, Tom.

Other cat illustrators include, P. C. Vey who created three cartoon books featuring his life-long favourites, despite both his wife and himself being severely allergic to them), Jean Cocteau, Pierre Corsen and, of course, Walt Disney and his talented team.

Martin Leman may not quite have broken Louis Wain's record of having produced for a significant time, more than a thousand drawings of cats a year but certainly a similar compulsion and indeed obsession attends him. He is notoriously happier to paint his cats rather than be scrutinized about them. Rather like the classic answer as to why one should bother to climb Everest, the answer is similar – because it's there. One might actually be grateful that Leman is not quite so obsessed or compelled, for Wain steadily descended into madness and ended up in the Middlesex County Mental Asylum – before, that is, being rescued by none other than H.G.Wells (a cat lover himself) who wrote a broadcast appeal on his behalf. The Prime Minister even intervened and under his aegis and influence had Wain moved to a specialist hospital. Such is the power it seems, of those in the 'cat club'.

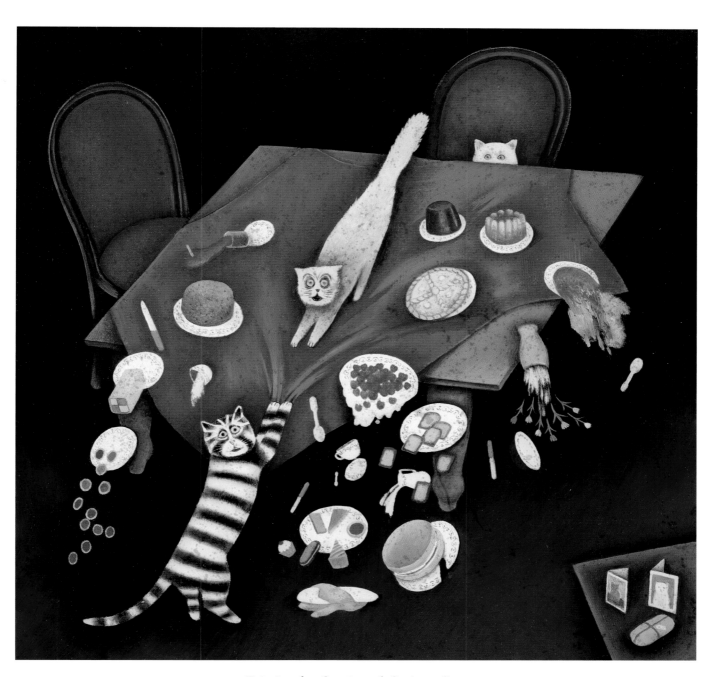

Painting for Comic and Curious Cats
1979
Private collection

Martin Leman's fascination with illustrating cats goes back to 'Comic and Curious Cats', in 1979. It was to become known in the publicity world as 'The Martin Leman Sales Phenomena'. By 1990, Pelham Books (now Leman's main publisher) was able to claim that it had sold 460,000 copies of his books and colourful calendars. Cat illustrations, accessible and desirable, then began to be applied to all sorts of affordable giftware products such as greetings cards, boxes, trays and jigsaws – the depth, colour and variety of the animal finding instant buyers who were owners, cat lovers – or simply those who knew their friends were.

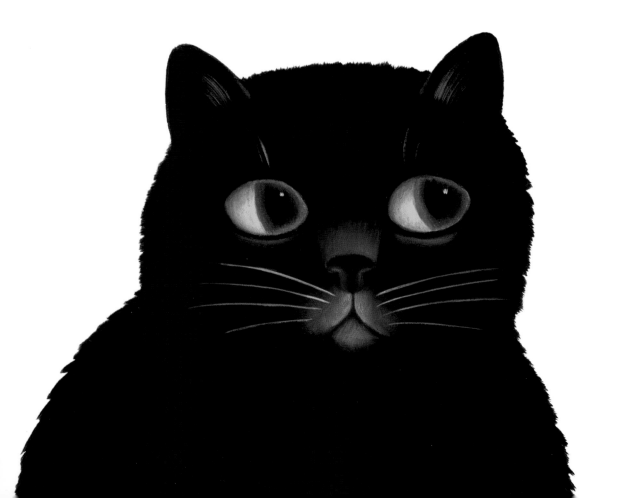

From the very cover of 'Comic and Curious Cats', Leman provides an obvious clue as to his stance and style. And whilst not exactly a children's book is certainly appealing to the child in us all. The insistent hypnotic eyes of the pin-up cat star on the cover is welcoming, warm and friendly. It appears to be somehow very human and approachable and there is more than a suggestion of a smile about its lips. The Cheshire Cat looms again?

The overall composition of the image – with sky, field backdrop and cat 'portrait', sets up a Leman template; for whilst there are these three elements of the image, the overall impression is one and not two dimensional, certainly an aspect of his naive style. He is always quick to describe his work as 'flat', in conversation, almost like an artistic raison d'etre. The cats on these pages all display a certain overt or covert sense of quiet, yet knowing, humour. And it is a humour wanting to be shared.

In 1977, Joanna Goldsworthy, the children's book editor of the renowned publishers, Victor Gollancz discovered Leman for the publishing world. She had seen his work and asked him to do his first cat book. With a practiced eye and knowing what would appeal to children (and perhaps, children of all ages) Goldsworthy saw what so many do in Leman's approachable, friendly, seductive and cheekily mischievous style.

Painting for The Little Cats ABC book
1993
Private collection

This style, coupled with her choice of Angela Carter as writer, was a clever move. Carter had already established herself as a novelist, poet and essayist of some note and one who also displayed more than the sense of the macabre and surreal, inspired by traditional fairy tales and myths. She had won several major literary prizes. Such was the initial (and then continued) success of 'Comic and Curious Cats' that the book was translated into several languages – including Japanese.

Following this phenomenal success, 'The Teeny Weeny Cat Book' – deliberately diminutive and 'cutesy' sold 55,000 copies in twenty-four months and Leman's calendar sales reached 44,000. As writer David Buckman has pointed out, 'Lemania' had broken out. 'Curioser and Curioser Cats' followed in 1990 and then, 'The Little Cat's ABC Book' in1993.

In 1994 came 'Cat Portraits' and the next year, 'Ten Little Pussy Cats.' All these were under the aegis of Gollancz who obviously saw in Leman a constant and inspiring well and a sure-fire seller. Orchard Books produced 'Sleepy Kittens' in 1993, and Brockhampton Press issued Martin Leman's 'Cats' in 1996.

Leman shares a time-honoured technique with many artists and illustrators when it comes to depicting images for children. Naturally, these cats have to be attractive. They have to be friends, confidantes, clowns and perhaps even teachers. The wide-eyed and playful are only two aspects of their lives. Moral and instructive tales follow them at close quarters. How to behave in the human sphere of existence is often more palatable, when transposed into the lives of familiar animals. Aesop, as we know, could hardly have chosen better when he selected a bevy of animals to teach humankind what it should know anyway.

Painting for The Little Cats ABC book
1993
Private collection

Painting for Ten Little Pussycats
1995
Published by Victor Gollancz
Private collection

Leman's colours are candy-sweet or primary sharp and all with a story to tell. Often shown in the midst of trouble or cheeky mischief (much like the young readers might like to get into). Leman's cats knock over a coffee cup, claw down a teatime spread or play hide and seek in a milk jug. These are cats to smile about and laugh at – and with their exaggerated features and deliberately rotund, child-friendly faces and forms, they are instantly appealing to children. And if we need to reiterate it – children of all ages.

Painting for Sleepy Kittens
1993
Private collection

Painting for Sleepy Kittens
1993
Private collection

Painting from the Little Kittens ABC Book
1993
Private collection

Painting for Sleepy Kittens
1993
Private collection

Paintings from the Little Kittens ABC Book
1993
Private collection

Paintings from Star Cats
Oil on board, 1980
Private collection

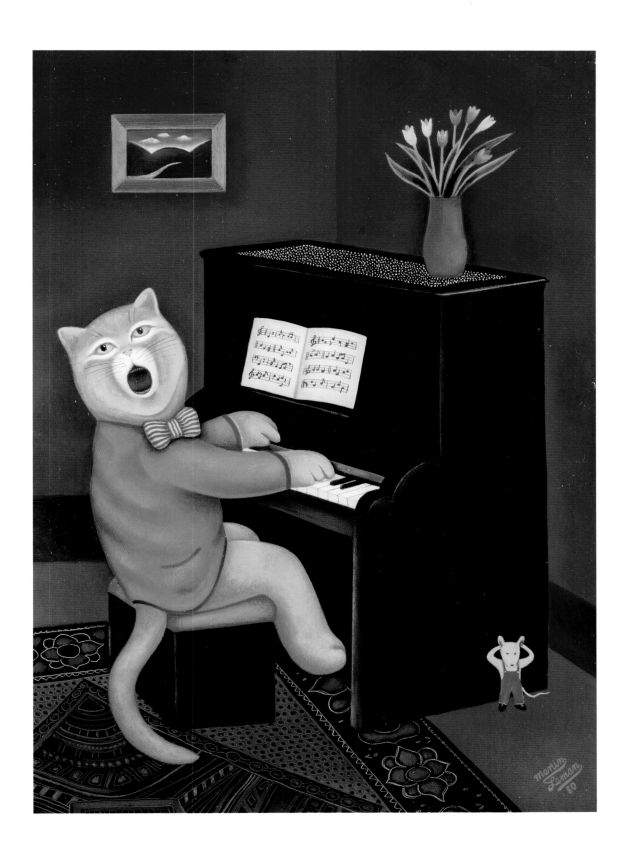

Chapter 6
Day

For at the first glance of the glory of God in the East

He worships in his way.

From 'Of Jeoffrey, my Cat'

by Christopher Smart

CATS ARE ESSENTIALLY semi-nocturnal. In other words, they want the best of both worlds. But despite their being as comfortable with the day as with the night, most people believe that they share more with the darkness. They seem natural allies of the night. Their keen eyesight, sense of balance and way of camouflaging themselves in mists and rime rings altogether more clandestinely true. Of course, they are just as happy underneath the shade of a laburnum at high noon, or curled up in front of a teatime autumnal fire in the parlour, but still the dusky image persists.

Still for all that, the daytime cat is a fascinating – and very different – animal. In the original and some might say slightly obsessive poem as a paean to his cat, Jeoffrey, Christopher Smart, with the characteristic 'For' beginning each line like a prayer or mantra, examines the nature of his feline in minute detail.

For in his morning orisons he loves the sun and the sun loves him.

White Kitten
Oil on board, 1982
40 x 30 cm
Private collection

Smart makes this point, significantly after explaining how his cat is totally at ease during the velvet dark hours of night. 'Night's adventures and quiet restful days' is the balance of the cat which Scottish professor and poet, Alexander Grey puts it – speaking of the seductive purr of our subject. And even that purr changes by day and by night. At night, the cat's voice seems intent on being heard, a territory claimed or reiterated, a Queen calling for her mate, a Tom screeching at the stars. But by day the deep and resonant purr and lower tones seem to indicate a quieter life – no doubt gearing up for a long night ahead. There is a myth attached to this aspect of a cat's expression – that its very purr, velvet melodic, has the power to heal its owner. Fanciful feline stuff, perhaps but certainly a rather seductive idea and one that seems to fit with the nature of the beast.

Whilst it may be true, as the old saying goes, that 'all cats are grey in the dark', by day they emerge in all their parti-coloured, brindled, spotty, dotty, single hue brilliance. It is plain that Martin Leman loves the way that pattern and colour are evinced by the sun in the opposite way a cat's silhouette is pronounced by the night.

Myths surrounding cats by day are almost as numerous as those concerning the night. Old beliefs, myths, superstitions, persist – and seemingly, the more bizarre, the more tenacious. It is a generally held belief by many that one can tell the time from the size of a cat's pupils – and one doesn't have to go to the trouble of puffing on a snatched dandelion clock to boot. Another curious one runs along the lines of being able to tell the time of day by analysing the shape of those eyes. But of course you may not have your favourite pet with you at the office.

Cat on Wall
Oil on board, 1981
30 x 40 cm
Private collection

Martin Leman

Cornish Cat
Oil on board, 1982
Private collection

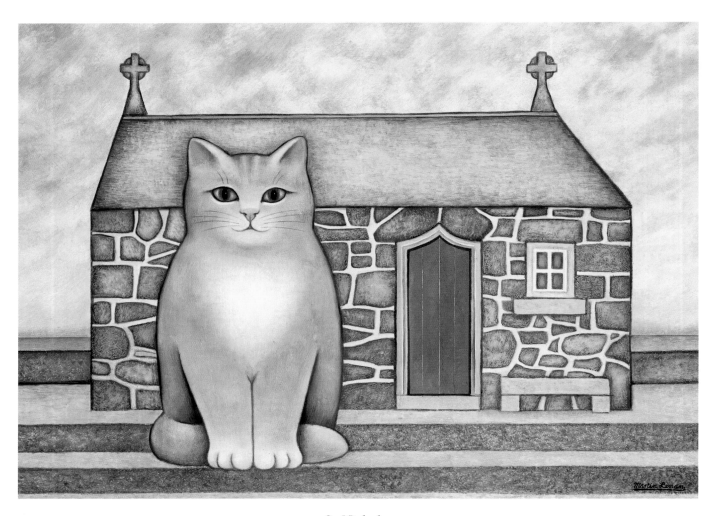

St Nicholas
Oil on board, 1976
25 x 40 cm
Private collection

Martin Leman's daytime cats allow him to explore the full potential of the colour and pattern of his various subjects. It is impossible to say exactly what colour domestic cats were originally but it is plain, especially to cat lovers, that there are no unattractive felines, even perhaps the rare and curious Scottish Fold which looks as if it has had one fight too many with its flattened ears. This was a naturally mutated breed that appeared in Scotland in the 1960's.

Colette seemed to champion cats at every given opportunity.

> It is the animal to whom the Creator has given the biggest eye, the softest
> fur, the most supremely delicate nostrils, a mobile ear, an unrivalled paw,
> a curved claw borrowed from the rose tree.

High praise indeed and extraordinarily visual. Martin Leman loves to explore the almost impossible possibilities of marking, pattern, camouflaging and the veritably Art Deco styling of sleek and elegant hues. Whilst it is a given that all cats have the same morphology – even specific breeds and extreme cases apart – no two cats, even siblings are exactly the same. As has already been noted, the Egyptian word for cat is 'Mau', a recognisable interpretation of its voice. But also, this word happens to mean 'light' – perhaps derived from the fact that, according to various beliefs around the world, that cat's eyes appear to glow in the dark. The ancients believed that cats' eyes held sunlight and keep away evil night spirits. Whether this manifested in actuality with the freezing Mrs Edgar Allen Poe clutching her cat for warmth and covered in her husband's moth-eaten overcoat or the practical use of a cat by eighteenth century ladies who often had mice nesting in their high hair, the fancy is just as strong.

Martin Leman's daytime cats do not appear to own such ancient or literary gravitas. All, without exception, are approachable, comfortable and masters and mistresses of their own favourite perch or patch, be it a sunny window sill, garden wall or bed of flowers. Amongst the tabbies, tortoiseshells, smoke shorthairs, blue-creams, bicolours, creams and jets, Leman finds inspiration. And with his daytime cats in particular, one might attempt to trace a link to his connection with St Ives.

Smeatons Pier
Oil on board
40 x 50 cm, 1983
Private collection

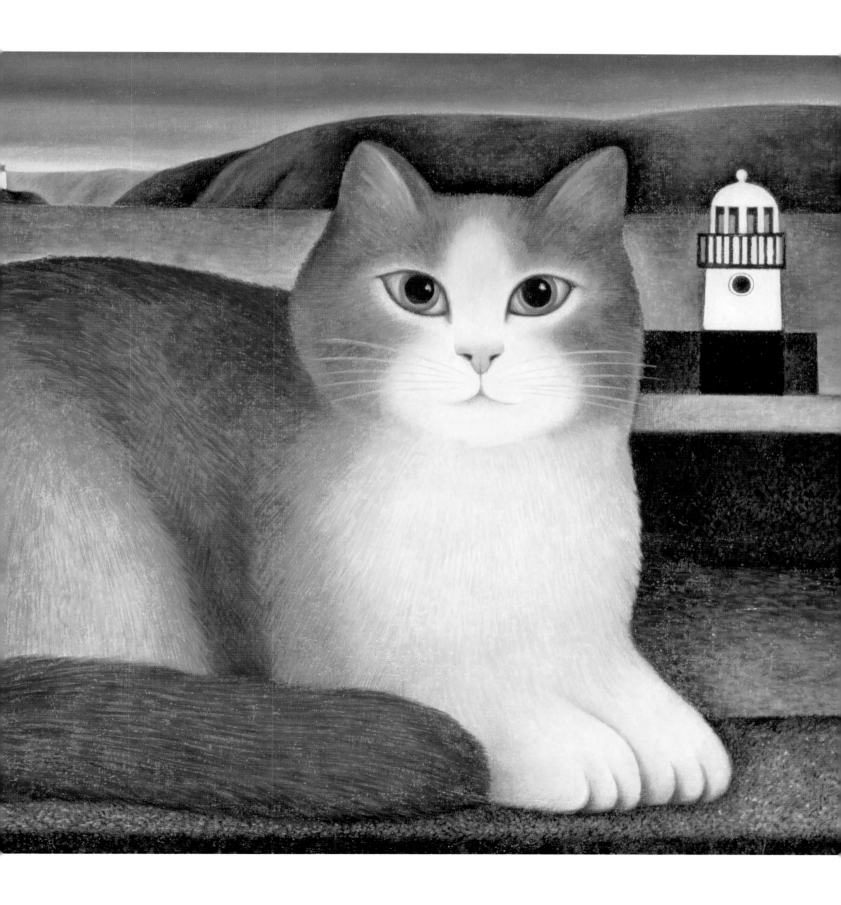

Leman has always had a strong connection to Cornwall and through the 1970's visited Penzance and St Ives as a matter of course. Much of the time, he spent teaching but also working on new canvasses inspired by the sea which often provides the contrast backdrop for several cats. He began painting the cats of the town of St Ives and in 1987 the book 'Art About St Ives' was published with one of Leman's paintings gracing the cover. In 1993, one of Leman's St Ives' paintings was made into a limited edition print, the sales of which went towards the funding of the new Tate St Ives. In this work, a snowy white cat sits amidst some abandoned, half finished canvases with a palette, an Hepworthesque sculpture on a plinth with a telescoping view of a typical St Ives seascape with extending visual devices leading all the way to a far lighthouse but incorporating roof top, cottage on the edge of the land, fully blown sail and an eerily white early sun.

What St Ives taught Leman, possibly more than anything else was the quality of light. His canvasses all seem to have that white-sun chalkiness, fresh and clean. It is that quality of light and the shapes that man-made or nature-made objects on the seascape create that have inspired so many artists. All the St Ives paintings seem to show day in a characteristically familiar way.

There is an old Rumanian folktale concerning why cats sit on doorsteps in the sun. The story goes that when Noah built the ark, he kept the door wide open for all the twinned animals. Calling to his wife to get on board, she refused, initially. In anger, he shouted, 'Oh, you devil, come in.' The Devil hearing this took it as a direct invitation and changed himself into a mouse, the better for disguise amongst the animals. Once safely aboard, the devil-mouse began gnawing into the floor timber to sink the ark. When Noah saw this, he threw a fur glove at the creature and it instantly became a cat which immediately caught the mouse.

Rather unkindly and ungratefully perhaps, Noah threw both overboard. The cat let the mouse go and swam back to the ark where it lay on the doorstep to dry herself in the sun. And, so the story concludes, cats have loved basking in the sun, on a doorstep, ever since. As for the released mouse? There was (and still is) little love lost between both feline and rodent.

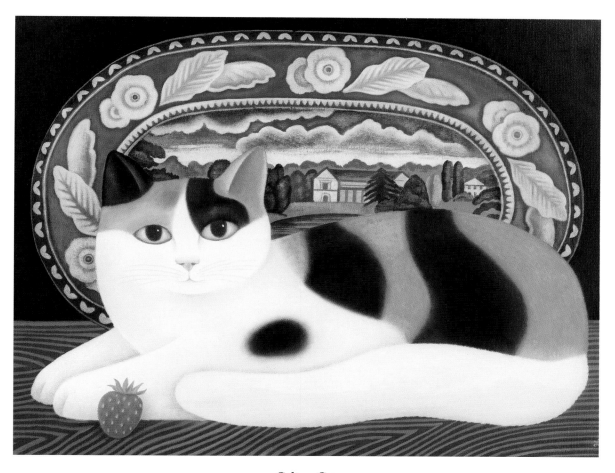

Calico Cat
Oil on board,
Private collection

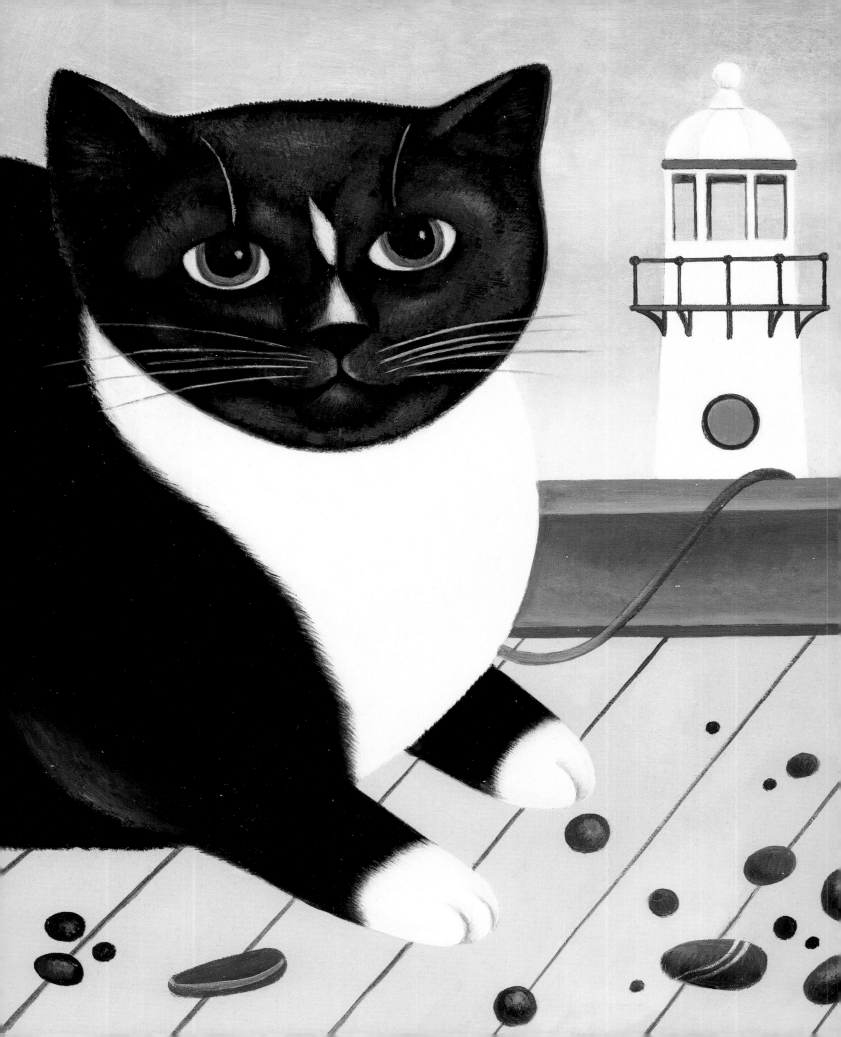

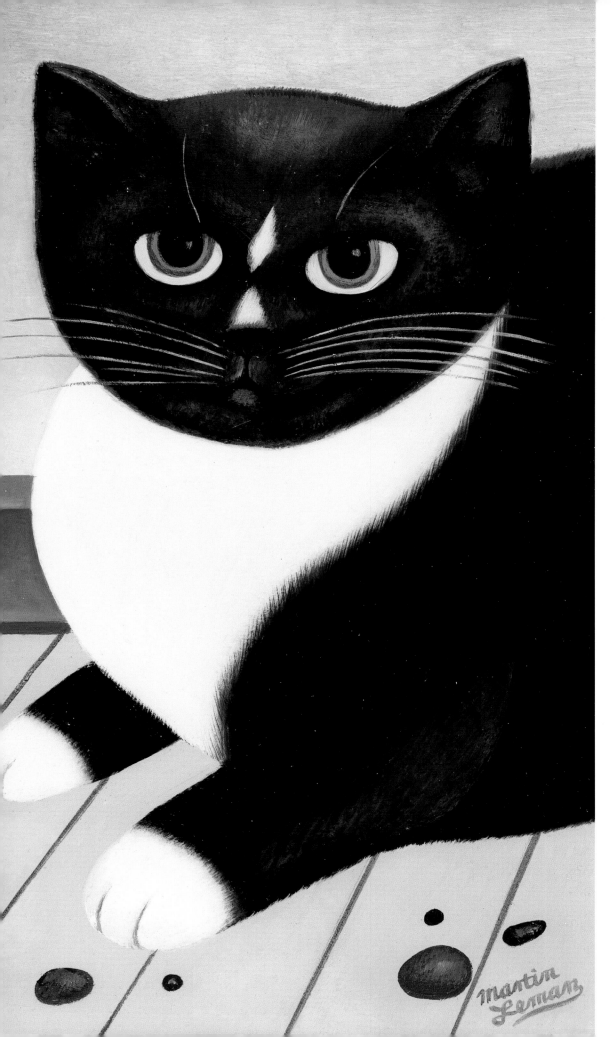

Boswell & Johnson
Oil on board, 1983
40 x 50 cm
Private collection

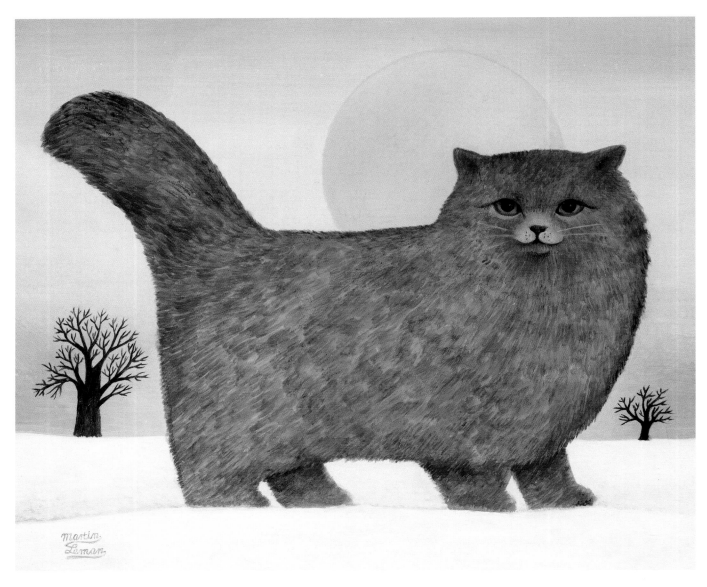

January
Oil on board
Private collection

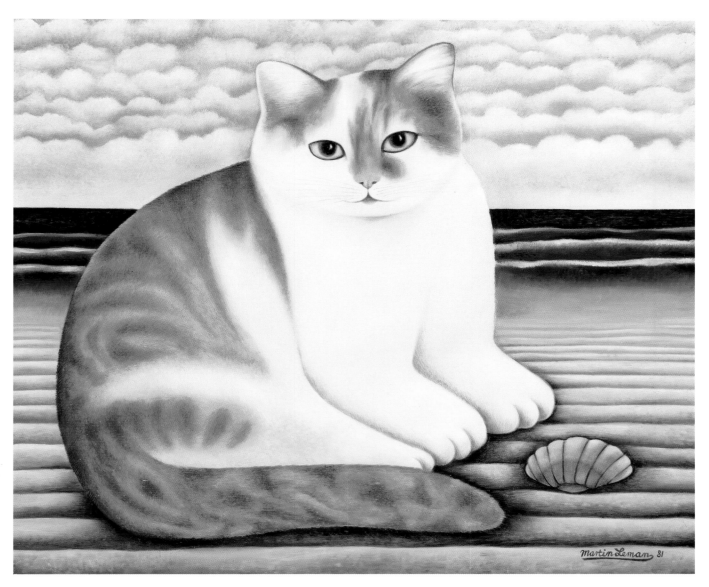

On the Beach
Oil on board, 1981
Private collection

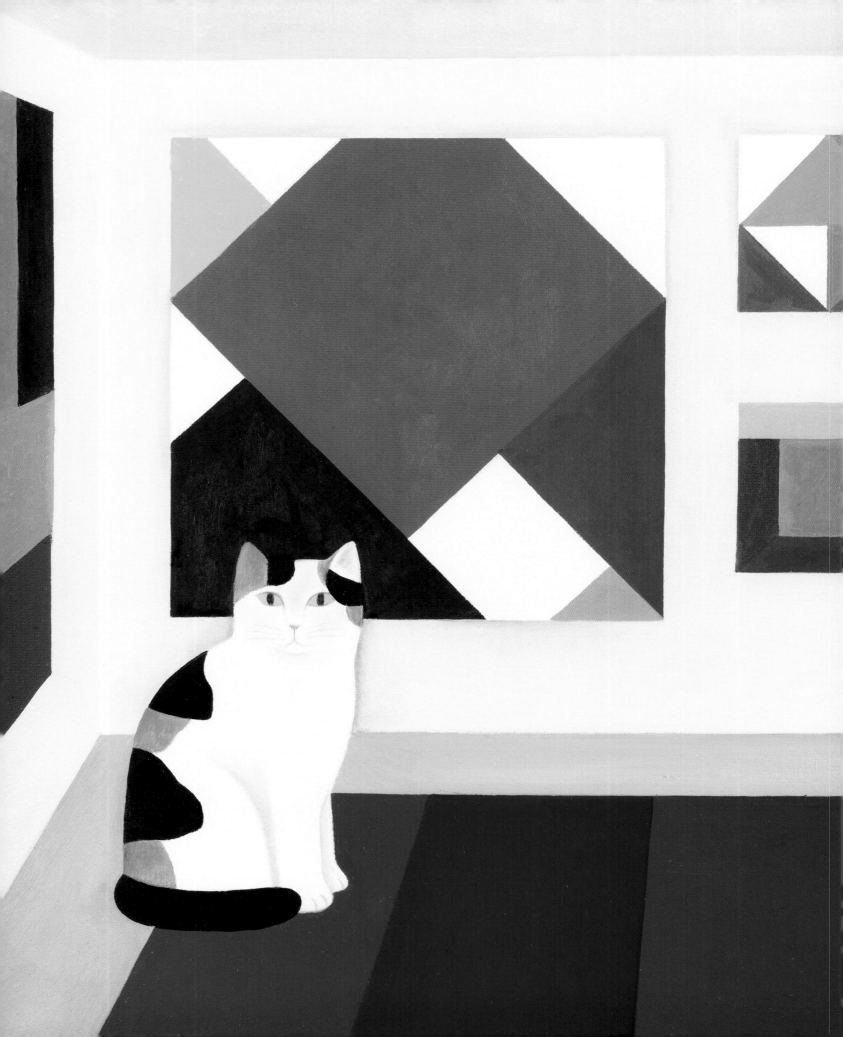

Chapter 7
Pop

I am the cat of cats. I am the everlasting cat!

From the 'Cat of Cats'
by William Brighty Rands

THE INFLUENCE OF the Pop Art movement in general has been both immediate and of course, lasting. Pop or 'popular' imagery was drawn from everyday objects and addressed 'popular' preoccupations. Arguably, arch pop-meister himself was Andy Warhol, who seemed to want to engage every housewife in the world of art, by bringing into the gallery context, products which were more tangible on supermarket shelves.

Marcel Duchamp's early twentieth century experiment with irony that helped pave the way for the Surrealists then still influenced in some part, the new explosion of Pop Art. The bold lettering, mass consumerism and especially colour are all aspects of Pop Art. Television, of course being years away from the sitting room essential was beginning to influence viewers and advertising by becoming more and more sophisticated and there was a definite suggestion that as the song of the time went, if you wanted something – there it was, so you had better come and get it.

Painting for Curiouser & Curiouser Cats
Oil on board, 1989
30 x 30 cm
Private collection

There was a direct link between Pop Art and consumerism and it may be as well to remember that Warhol had started his career as a graphic artist drawing fashion shoes.

The late and hugely influential art dealer Robert Fraser, who was responsible for introducing several Pop Artists to an English audience, remembers the time as 'one of brilliant optimism – a time of coke and crisps', How firmly his tongue was in his cheek regarding the first, one will never know. There was certainly a feeling of daring and innocence and experimentation – a curious social salad. Much of the imagery and many of the sculptures from this period are ironic and consciously knowing or playful. All these hallmarks one can discern in a good deal of Martin Leman's work.

Perhaps the most significant connection between Leman and the Pop Art scene was London's Portal Gallery – which, whilst of course ploughing the Naive and Primitive art furrow, was still a definite part of the greater swell. Indeed some of its artists could not but help be influenced by the prevailing wind that was Pop Art and incorporated elements of it into their very particular work. Leman did much the same with a number of his canvasses. These works featuring cats in more comic attitudes are vibrantly coloured, playful and comic.

Leman began showing with the Portal Gallery in the early 1970's when Pop Art was certainly well established as a movement. After the stranglehold of the 1950's preoccupation with Abstract Expressionism, Pop Art, with its direct, unashamed and enthusiastic appeal, reflected the fashions, the music and much of the domestic design agendas of the time. Certain recognizable devices are discerned in Leman's 'Pop' paintings – that classic (and perhaps too ubiquitous) Bentwood Café chair with the criss cross wicker seat, the geometric, highly coloured colour blocks and indeed, the actions and attitudes of Leman's subjects themselves.

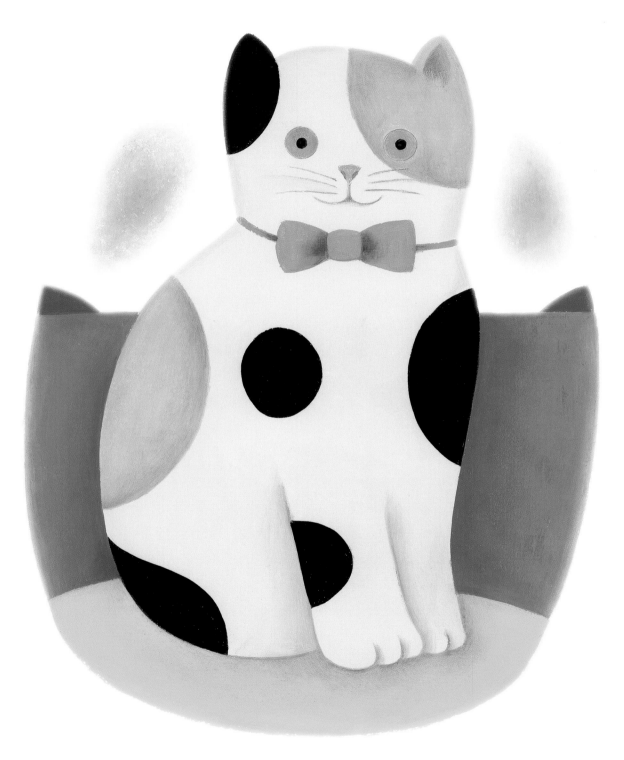

Postcard
Oil on board, 1992
Private collection

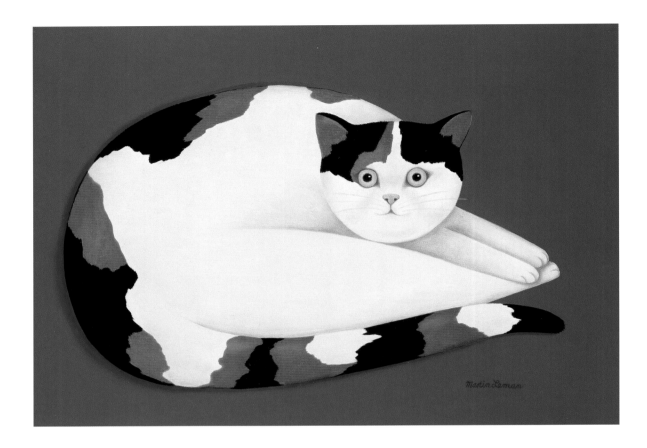

Another aspect of Pop and Leman is simply the reality that cats in themselves are simply 'popular' – as pets, advertising motifs, design icons on especially children's wear and so on. Advertisers discovered early on that the use of this familiar creature attracted immediate attention. Even today, a cat guarantees attention in a more than competitive and ruthless market with similar products pitching against each other. Think Frosties, Esso, Kotex and then of course, the cat food industry of course, with the likes Felix, Sheba and Whiskas.

Paintings from The Little Cats ABC Book
Oil on board, 1993
Private collection

Painting from Starcats
Oil on board, 1980
Private collection

Right: Valentine
Oil on board
40.5 x 30.5 cm
Collection of John Maxwell

Patch
Oil on board, 1980
30 x 30 cm
Private collection, USA

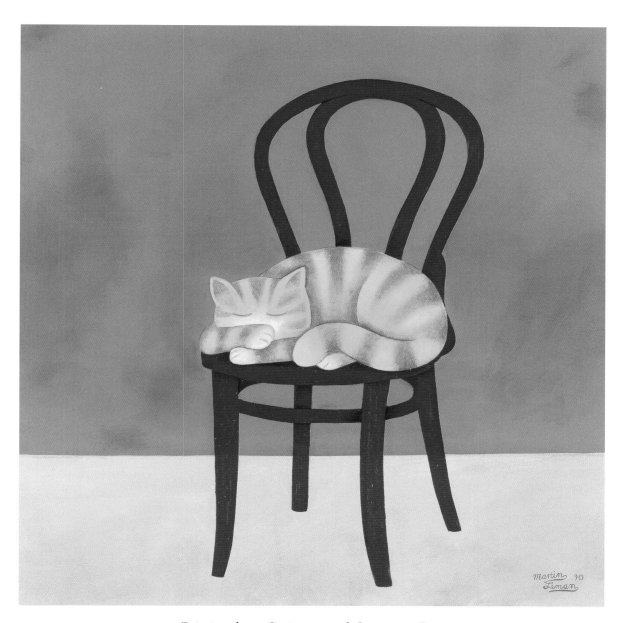

Painting from Curiouser and Curiouser Cats
Oil on board, 1990
30 x 30 cm
Private collection

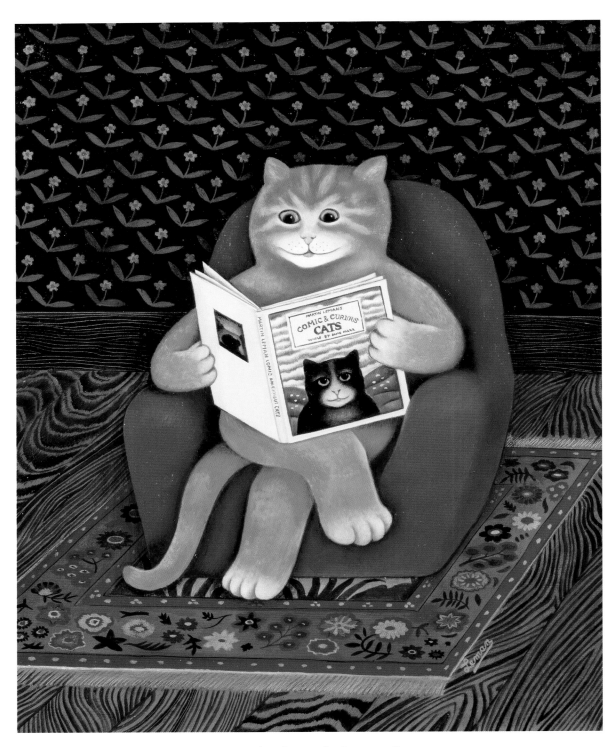

Painting for Comic & Curious Cats
Oil on board, 1979
Private collection

Greetings Cards, 1987

Chapter 8
Prints

Ye shall not possess any beast, my dear sisters, except only a cat.

An English nun's rule circa 1205

THE WORLD OF printing and engraving represents a daunting challenge to most. Whereas painting and sculpting can often be undertaken at a certain, measured pace, printing often relies on time, precision and the fact that in many cases (if tracing paper is not utilized) the image has been created 'in negative' to enable the result to appear in the positive.

To Martin Leman, prints are certainly hard work but exciting and unexpected. 'It's a different challenge to me', he admits, 'and it's certainly a different way of working. You don't use paint or brushes, of course but instead, a burin, a piece of pointed metal and a copper sheet.' The limitations of printing are what makes this discipline a real challenge.'

Many artists like to experiment with the possibilities of printing because of the varied results – however subtle – which different pressures on the surface can produce. Many can be discarded and deemed unsatisfactory. One really has only one chance after the print has been laid on the paper and then lifted off. The copper plate 'page' itself also has a limited life and is almost always discarded after a given printing run – although Leman owns to have kept one or two as souvenirs, which of course will never be used to print from again. 'It's very labour-intensive and not run off on a machine', reminds Leman.

Two Cats
etching
Private collection

Although of course, prints can be very complex and involved in the main, most remain deliberately immediate and exact – flat and quite uncomplicated, possessing a tangible 'design' quality and a certain stylization. They appear simpler because of this and the use of one or two colours highlights this. Leman's interest in the possibility of experimenting with printing and adapting his usually florid and bold style to it, goes back over two decades. Close to his home was an etcher, Hugh Stoneman, who introduced him to the techniques of printing and all its often frustrating complications. Leman had of course, by then made his reputation, sold several books and various giftware items – all of which bore his hallmark felines – but he had not tackled printing as an artistic discipline. At around this time, Clarendon Graphics approached him to create prints which could be treated almost like a shop product rather than a gallery item, obviously because of its accessibility and lower price point, encouraging those whose pockets were not ravine deep.

This also brings problems. Work which is limited by edition can be frowned on by 'one-off purists' simply because it is an edition. The fact that it is impossible to create more than a certain amount, that each one could be (and is) very different to its neighbour and also the plain truth that prints are an attractive and accessible way to collect works of art on a frequent basis, makes little indentation on them. Leman himself acknowledges the purist problem but is also the first to say that prints are definitely appealing, attractive and accessible.

One example proves this well. At one Royal Academy Summer Show, Leman displayed a certain print of a cat in a playful and comic attitude, which proved to be instantly popular. Entitled 'Waiting,' the irony was that it didn't have to wait all that long to have a queue of about 100 names signed up to own one.

Leman remembers the whole episode very well. 'I think it was quite a strong image and people simply responded to it. It was an amusing picture – quite punchy and well designed. It was later made into a greetings card and is, I believe, still sold at the Academy gift shop.'

Country Cats
Lithographic print, 1985
Private collection

'Waiting' betrays all the print preoccupations of Martin Leman. Strong delineation of line, sparse and minimal (although also very well placed) colour and an undeniable style, which leans to the Oriental in concept, are all the telling hallmarks. Leman's prints in general, are quite naturally simpler and one-dimensional and with the usual colour volume turned down to barely audible. Perhaps in some way, they recall, the artist's images of St Ives scenes with the obligatory cat in the foreground. And in image after image, a reminder of Oriental techniques in essence and perhaps Japanese qualities in particular, typify Leman's print style. Undoubtedly, they also have that immediate and endearing appeal one often finds on the pages of children's fairy tales or poetry books.

But it is certainly the Japanese influence, to which Leman returns to explain his fascination with the medium of print. 'Japan is famed for its prints,' he says. 'Japanese prints are well and beautifully designed – not haphazard scratches like so many can be. They are precise and show great craftsmanship.'

But as in so many areas of life, new technology is making its presence felt. Leman wonders how long the actual process of printmaking can survive when today one can achieve stunning effects cheaply and effectively and of course more speedily than ever before. Careful use of hand made, thick butter yellow or snow white paper, a great modern or antique frame and you have a work – the least expensive element of which is the work itself.

Scrufty
Etching, 1981
Private collection

Amber
Etching, 1983
Private collection

Cat Nap
Etching 1982
Private collection

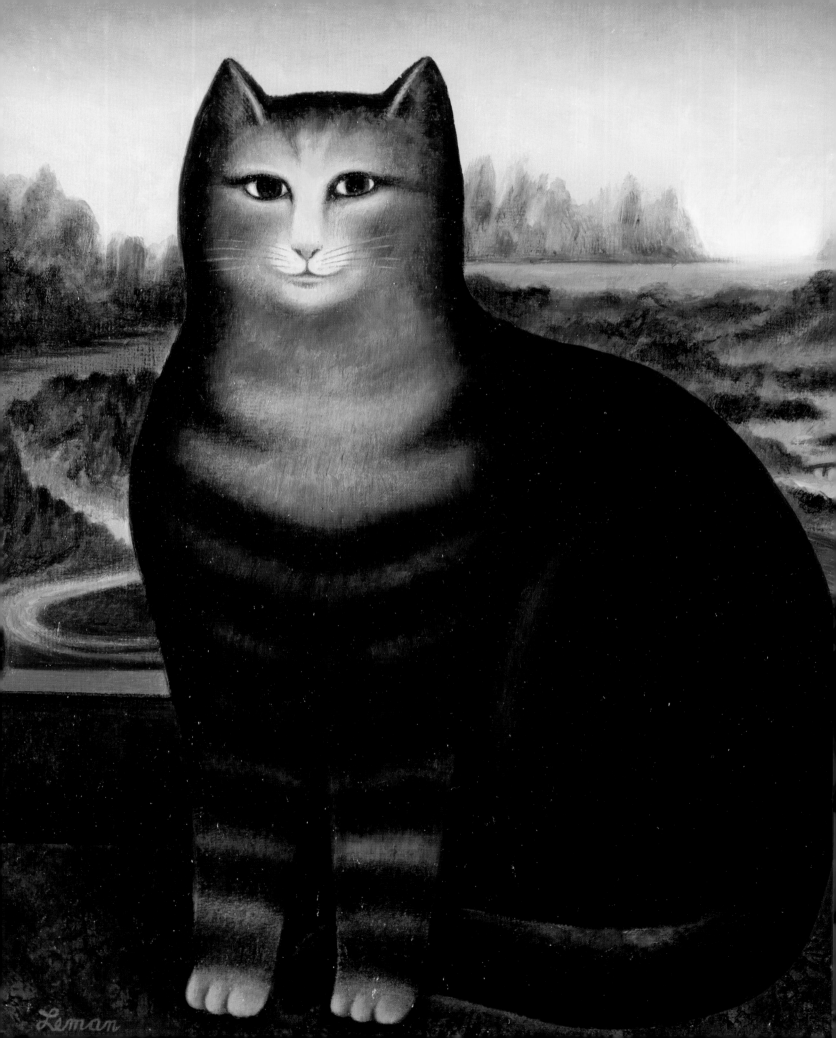

Chapter 9
Homage

Everyhing that moves, serves to interest and amuse a cat.

F. A. Paradis de Moncrif

MARTIN LEMAN HAS often been inspired to depict cats in the style of some of his favourite artists. Far more than being perennial favourites, they are loved enough to become enmeshed with his preoccupation with felines. But before looking at his multifarious ability to mimic various painting styles and techniques, it may be as well to briefly recall how the cat itself has influenced so many legendary artists.

The cat has always been a favourite subject for artists and artisans from the earliest civilizations – appearing most famously, perhaps, on tomb walls, as central motifs in Roman villa mosaics, tapestries, paintings and as elegant sculptures. Not only did the Egyptians worship the cat goddess Bastet, but borrowed lioness and big cat's heads in general for many of their depictions of royal consorts and other deities. Perhaps because of the early associations with magic, mystery, a prized independence, pride and personality, cats seem to offer themselves as multifaceted inspirations.

Leonardo
Oil on board, 1980
Private collection

Symbols of liberty in ancient Rome and often found on coats of arms as visual legends of the bearer's pluck, luck and stealth, cats have an immediate resonance for the viewer – even if they are not under the spell of Ailurophilia – a morbid or inordinate love of cats. Cats insinuate themselves into human lives – and on their terms. So it is understandable, perhaps, that the artist who surely prizes his spirit of independence and self-determination above many if not most things, might find an inspirational ally and subject in the cat.

Cats are to be found in several paintings – many of them as symbols and motifs – telling devices to add a zest or angle to the whole. Antonello da Messina, Cellini, Dürer, Bosch and Leonardo da Vinci all painted cats, this last executing several images of cats in many of their feline expressions from a classic, sinister stalk to a familiar lazy stretch. Renoir, Gaudier Brezeska, Gaultier and Steinlen all admired the grace and elegance of the cat and the big cat. To a greater or lesser extent, these several appearances amount to a homage to this familiar yet often tactically and naturally remote creature – fascinating because of its inscrutability.

Martin Leman, when paying homage to his favourite artists, utilizes cats to create a wry, mischievous result. In the main, all are humorous. The combination of the cat form and a more than self-evident evocation of the style of a given artist goes for the chuckle first. In many of Leman's homage pictures, the cat featured looks supremely and amusingly out of place. For example, in two of Leman's most memorable homage pictures, he tips his hat at Leonardo with ironic twin versions of what must be the most famous and (perhaps because of the often uneducated adulation) unliked painting in the world, the Mona Lisa.

In the first, 'Did Leonardo visit St. Ives?' Leman exercises a knowing and very mischievous wit. Here sits a pretty keen and relatively realistic version of the lady in question but she holds an ironic Tortoiseshell in her arms and the purposefully minimalist backdrop echoes a naive classic St. Ives scene complete with lonely beached boat, lighthouse and distant cottage. All this about as far as you can get from the warm Italianate clime.

In the second, just as ironically titled – this time for its blatant and comic simplicity, 'Mona Lisa' shows the famed sitter puffed up and plumped out, as if having had a steady stream of air pumped into her, looking more like a cartoon than an iconic work. A similarly naive, rotund, marmalade feline is barred escape by a robust, robed forearm. Like owner, like pet. One can't help smiling at a work such as this – partly because of its delicate irreverence but also because it is genuinely funny. Leman likes his little clue-jokes and sprinklings of mischief and creating gentle homages with more than a hint of a smile is satisfying. In this version of the Mona Lisa, even the semi-indistinct trees and shrubs in the background are a little 'overweight'. All the same, despite being larger of course, this Mona Lisa sports the discreet suggestion of a diaphanous forehead veil. This is hilarious too.

Leman pinpoints the early Italian painter, Piero della Francesca, whose work he had seen illustrated in books, as a primary influence. This was in the late 1960's but even prior to this new ignition of inspiration on several visits to Paris, he had admired the work of Rousseau and Camille Bombois. Although rich, lavish and very detailed, the major characteristic of these artists was their tendency to flatten their imagery – certainly a trait of later (and earlier, of course) naive artists. By his own admission, he was specifically drawn to images with 'a touch of magic' and of course, that all important dash of humour.

Surrealist Cat
Oil on canvas, 2003
50 x 40 cm
Private collection

One stellar artist of enormous influence to not only individuals but also movements whom Leman actually met was William Roberts. Roberts' haphazard, yet supremely controlled, club and drinking scenes populated by artists and writers of the day was quite literally a blast for the Blast generation. The purposefully and purposely crowded canvases are instantly recognisable.

Leman admired Roberts' fine sense of draughtsmanship – his distinct and seemingly innate gift of shaping and sculpting the human form with colour and confidence and, perhaps most important of all, with a lively immediacy that renders the whole alive and energised, much like a cartoon or film can be said to be vital and alive. Leman remembers Roberts as an imposing character with rosy cheeks who occasionally taught the life class at the London Central School of Arts and Crafts.

Most, if not all of Leman's homage paintings, betray the same familiar flatness which is often associated with primitive, American 'Gothic' and naive art in general. It is a quality as much praised as it is derided. Naive art often has a tangible immediacy about it boasting, as it often does, poster-bright paints, eggshell glossy shine, impossibly proportioned props and luscious, rumbustious characters. It is also deemed non-intellectual – which might be a debating subject that could take a few moments to draw to a conclusion.

Perhaps one reason why Leman favours the illustrative approach – which is evident, even in the most painterly works in his oeuvre – is his connection with the world of commercial art, art direction and even magazine production. His own publication, Arcade was in

many ways an attempt at redefining design lines along with an new appreciation of imagery, the use of 'white space' and the need to communicate directly – much in the way a drawing or cartoon always has. And with homage under the spotlight, instantly, the viewer gets the joke, appreciates the intent and smiles at the result.

This same flatness can be discerned in one way or another in the works of say, Rousseau and Lowry which, whilst being worlds apart in terms of expression, colour, content and intent, are graphic, immediately striking – and memorable. This immediacy was to be a feature of much twentieth-century art from the Surrealists' psychological and dream imagery to the 'supermarket readiness' of Pop art in general – and Andy Warhol in particular. Warhol's imagery was of course vilified by some classical purists but, because of its harder and more strident edge and the artist's own inscrutable persona, his paintings became the vanguard and the template for many.

As a painting student, Leman learnt to get tonal details correct and proportions exact. But as a graphic designer, he learnt how to experiment with size, composition and colour so that reproduction of the 'real' becomes, perhaps, the last concern and imagination and rendering, the joint first.

In his series of homage paintings, Leman certainly displays the wide knowledge, research and learning he has acquired over the years. But something which the artist may be a little chary of sharing and declaring is a simple truth: his absolute confidence and ability to do so.

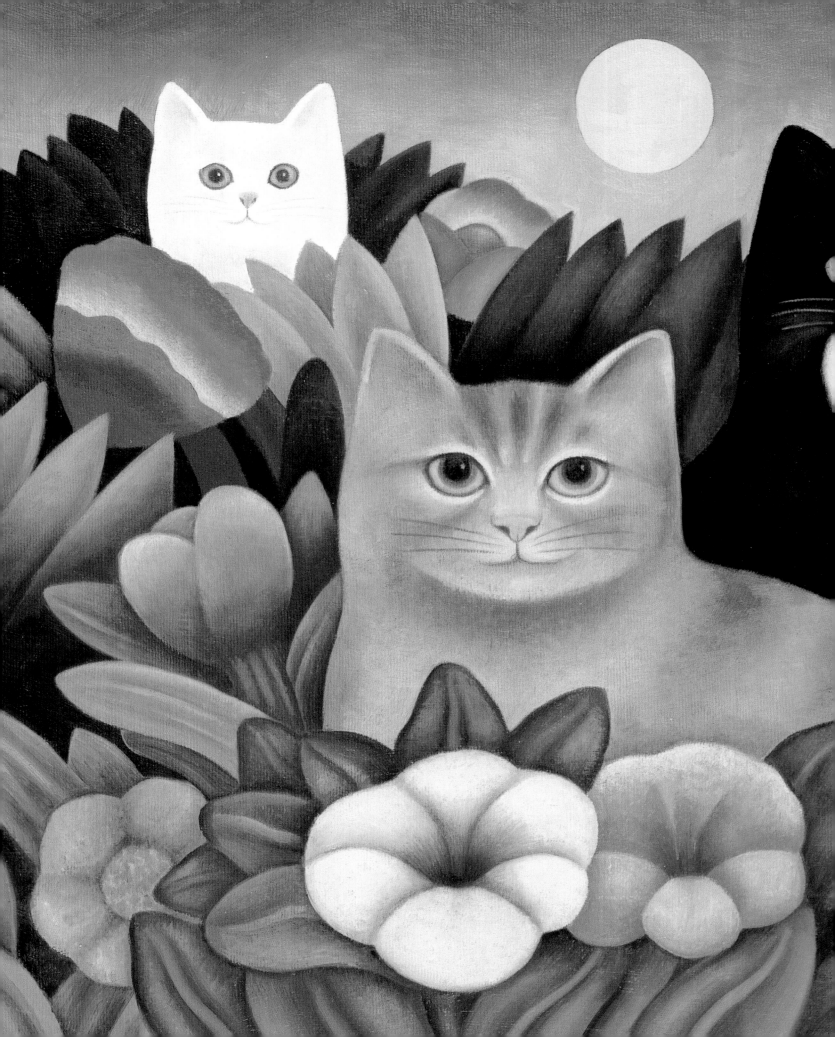

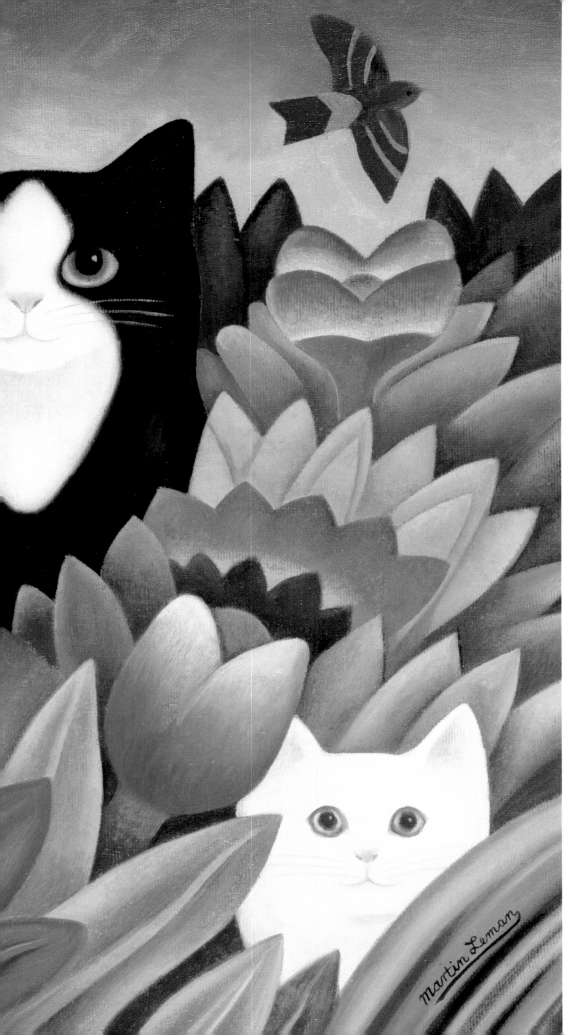

Rousseau Cats
Oil on board
Private collection

AGRICULTURE

* It used to be customary in Europe to bury live cats under fruit trees
to encourage growth of the trees.

* Peasants in Bohemia, Poland and Russia buried cats alive in their
cornfields because they believed it would guarantee a good harvest.

* In Transylvania black tomcats were killed and buried in fields on
Christmas Eve and also at the sowing of the first seed in Spring
to prevent evil spirits from harming crops.

GENERAL

* Girls were told to feed cats well so that the sun would shine
on their wedding day. (Wales)

* If you mistreat cats you will have rain at your wedding.
(The Netherlands and Ireland)

* If you are scared by a cat, collect hair from a cat or dog and
burn it under your nose. (Lithuania)

MYTHS

* A cat has nine lives.

* Neutered male cats become lazy and fat and do not hunt.

* You can tell the tide from the size of cat's pupil.

* Cat's eyes shine at night because they are casting out
 the night that they have gathered in the day.

* Warts may be removed by rubbing them with a male
 tortoiseshell's tail, but only in May.

* If you want to keep a stray cat at home, put some
 hair from her tail under the doorsill.

* A cat washing behind its ears means it will rain.

* If you want to keep a cat from straying, put butter on its feet.

* When you move to a new home, let the cat climb in through
 the window so that it will not leave.

* The Amish in America say that to keep a cat at home you should
 put a piece of food under your armpit and then give it to the cat.

1991 THE CONTENTED CAT, Pelham Books
 THE SQUARE BEAR BOOK, Pelham Books

1992 JUST BEARS, Pelham Books
 MY CAT JEOFFREY, Pelham Books

1993 THE LITTLE CAT'S ABC BOOK, Gollancz
 SLEEPY KITTENS, Orchard Books

1994 THE BEST OF BEARS, Pelham Books
 CAT PORTRAITS, Gollancz

1995 TEN LITTLE PUSSY CATS, Gollancz

1996 MARTIN LEMAN'S CATS, Brockhampton Press

2002 MARTIN LEMAN: A WORLD OF HIS OWN, Sansom and Company

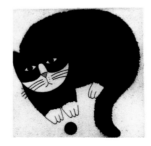

EXHIBITIONS

SOLO EXHIBITIONS

1971 Portal Gallery, London

1974 Portal Gallery, London

1979 Graffiti Gallery, London

1980 Graffiti Gallery, London
 Illustrators Gallery, London

1981 Print Show, Gallery 39, Manchester
 Graffiti Gallery, London

1982 Graffiti Gallery, London

1986 Blackman Harvey, London

1987 Cat's Meow Gallery, Tokyo, Japan

1988 Blackman Harvey, London
 Michael Parkin Gallery, London

1990 Andrew Usiskin Contemporary Art, London

1991 Andrew Usiskin Contemporary Art, London

1992 Andrew Usiskin Contemporary Art, London

1996 Coram Gallery, London

1998 Portal Gallery, London

1999 Rona Gallery, London
 Wren Gallery, Burford

2001 Rona Gallery, London
 Wren Gallery, Burford

2002 Rona Gallery, London

SELECTED GROUP SHOWS

1973 International Primitive Art Exhibition,
 Zagreb, Yugoslavia

1975 Centre Culturel De Levallois-Perret, Paris, France
 Art Naif, Galerie Contemporaine, Geneva, Switzerland

1976 Body and Soul, Arts Council Exhibition,
 Walker Art Gallery, Liverpool

1977 British Naives, Ikon Gallery, Birmingham

1978 London Naive Art
 Royal Festival Hall, London

1979 International Naive Art
 Hamiltons Gallery, London

1993 The British Art of Illustration 1780-1993
 Chris Beetles Gallery, London

1998 Children's Book Illustrations
 Cambridge Contemporary Art, Cambridge

2001 The Discerning Eye, selected by Sir Roy Strong,
 Mall Galleries, London
 Exhibitions in St Ives, Cornwall

2003 Wren Gallery, Burford

2004 The Mark Wilson Gallery, London
 Wren Gallery, Burford

1980-1990s Royal Academy Summer Exhibitions over the last 15 years

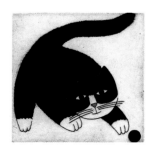

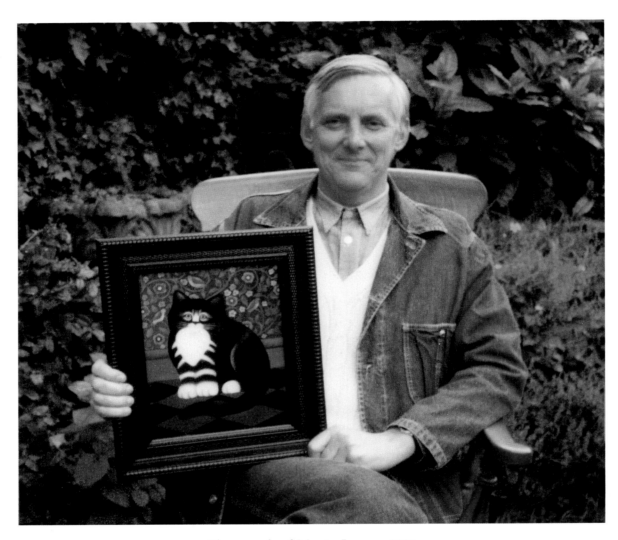

Photograph of Martin Leman, 2002